IMAGES OF AMERICA

BILL TAGUE'S
BERKSHIRES

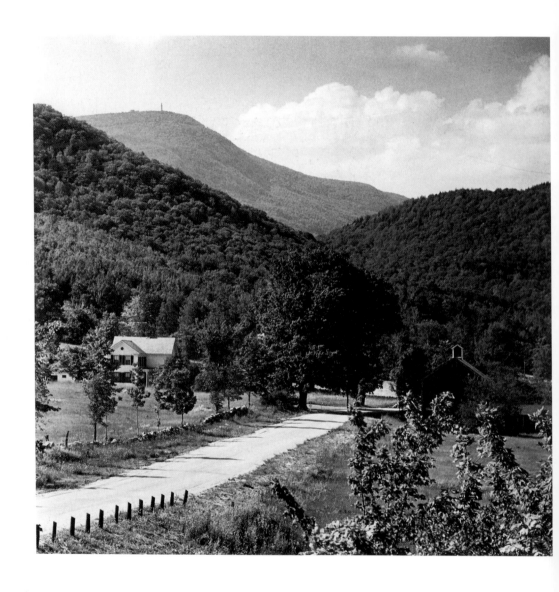

IMAGES OF AMERICA

BILL TAGUE'S
BERKSHIRES

TYLER RESCH

ARCADIA

Dedicated to the beloved grandchildren of Bill and Irene Tague: Celeste, Nora, Christopher, Alexis, and Eliza.

Cover Photograph: This pastoral scene is one of photographer Bill Tague's best-loved images, as well as a bestseller, in terms of the postcards of his work that have been sold in recent years by his wife, Irene Tague. The subject is their daughter Susan, when she was about five years old.

Frontispiece: One of Bill Tague's most appealing views of Mount Greylock, the highest point in Massachusetts, is this scene along the Fred Mason Road in the town of Cheshire. Greylock is instantly identifiable from any angle because of the veterans' memorial tower on its summit.

First published 2003

Tempus Publishing Limited
The Mill, Brimscombe Port,
Stroud, Gloucestershire, GL5 2QG

© Tyler Resch and Irene Tague, 2003

The right of Tyler Resch and Irene Tague to be identified as the Authors of this work has been asserted in accordance with the Copyrights, Designs and Patents Act 1988.

British Library Cataloguing in Publication Data.
A catalogue record for this book is available from the British Library.

ISBN 0 7385 1274 5

Typesetting and origination by Tempus Publishing Limited
Printed in Great Britain by Midway Colour Print, Wiltshire

Contents

Bill Tague's Record 7

one From on High:
Favorite Views of Mount Greylock 9

two Water (and Some Ice) 21

three Faces 37

four Prominent Residents and Visitors 63

five Women 81

six Those Cultural Berkshires 93

seven New Angles on Old Churches 119

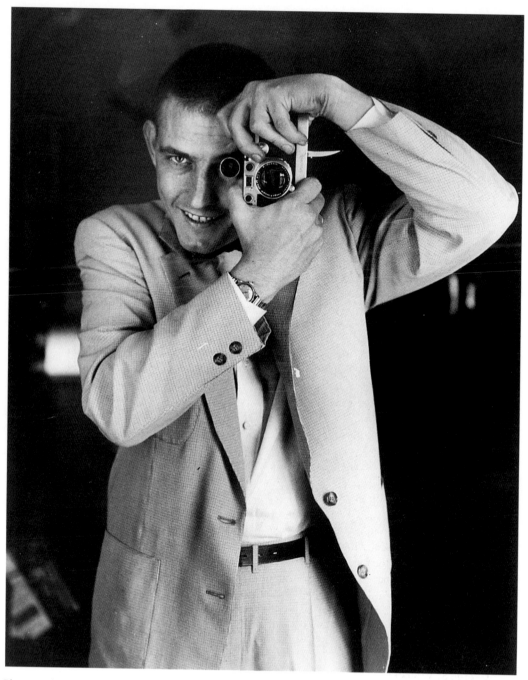

Photographer William H. Tague when Eagle Eye began, January 26, 1952. Tague published the weekly picture page in the daily *Berkshire Eagle* of Pittsfield, Massachusetts, until his death in November 1990.

Bill Tague's Record

Bill Tague was a regional photographer, working mostly within the Berkshires at a time which is slowly fading away. He was a reporter, editor, and photographer for the *Berkshire Eagle* when it was spoken of as a great newspaper. For many years, each Saturday Bill provided its readers a full page of photographs, known as Eagle Eye, with the result that he was widely known throughout the Berkshires. To assemble this page Bill roamed the countryside and culled old prints from his files. Over the long run his collected works make up perhaps the most complete document that we shall have of the Berkshires of his lifetime.

His portraits of everyday people and his mellow landscapes are so straightforward and quintessential that it is easy to recognize the Berkshires. These are the faces of the mill towns and the villages. His work shares with us the hardships, inadequacies, and contrivances that compose the real life of this community. Today many of the man-made structures which Bill photographed have disappeared, including the Pittsfield railroad station with its stately waiting room. Surprisingly, however, many of the natural landscapes seem to have endured.

Intellectual honesty and authenticity were of major importance to Bill. He could not abide what he called the phony. To which end, I might note that many in public life made sure that their tracks would not cross his path. He was often characterized by his gruff temper; but to his friends he was an endearing man.

Much of Bill's work was devoted to Mount Greylock (he lived nearby), and the mountain was very important to him. For most of his life he was engaged in running battles to protect the mountain from a series of ill-conceived commercial assaults that would have defaced the glories of this great prominence. Thus Bill's photographs of the mountain have particular meaning to anyone who thinks about the mountain as both a place and a symbol for the best qualities of this region.

We are lucky to have such a collection of photographs, which is now being preserved by his loving wife. And it is comforting to know that for many generations to come there will remain the opportunity to see the Berkshires as it once was through the eyes of Bill Tague. So it is we invite you to enjoy this book.

George S. Wislocki
President
Berkshire Natural Resources Council, Inc.

BERKSHIRE COUNTY

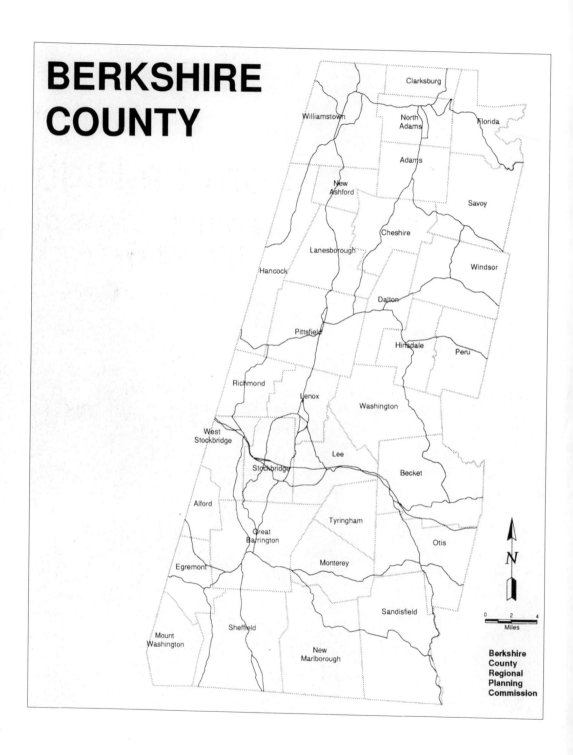

one

From on High
Favourite Views of Mount Greylock

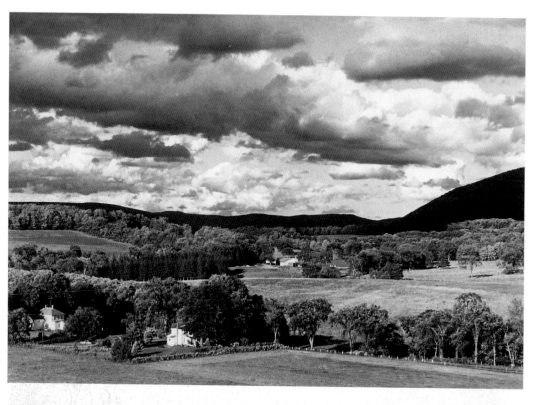

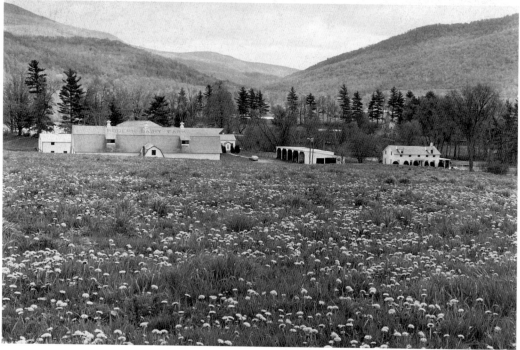

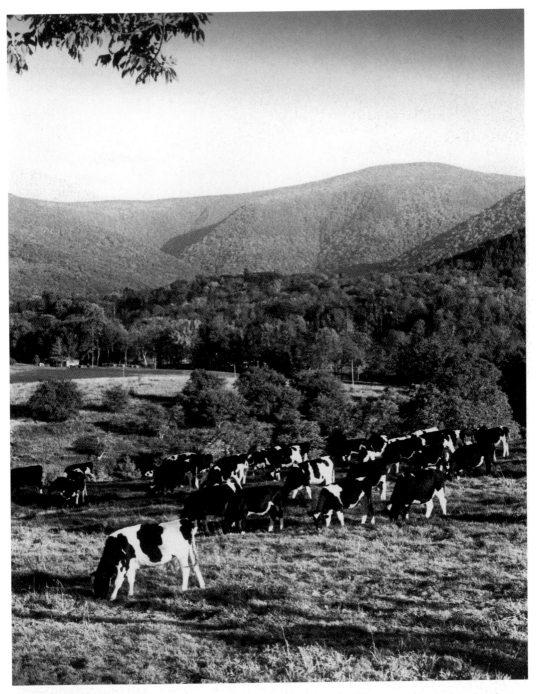

These three pastoral scenes taken around South Williamstown include a view, above, of cows with a backdrop of Greylock's "Hopper."

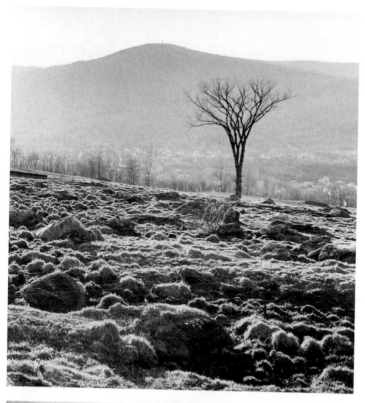

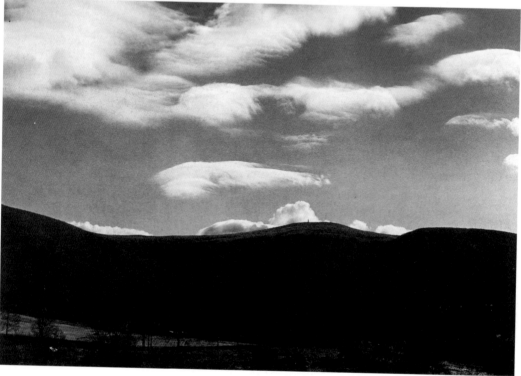

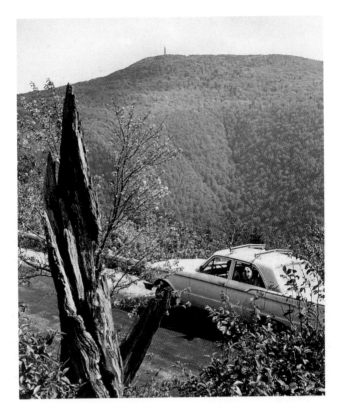

Mount Greylock's summit "needle" is the unifying theme of the photographs on these pages. Photographer Tague had special feelings for the dying elms and often recorded their skeletons, as in the scene at upper left, before they finally fell. The mountain is accessible, in season, by motor vehicle.

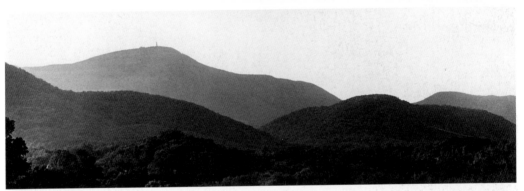

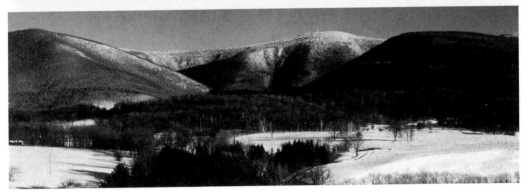

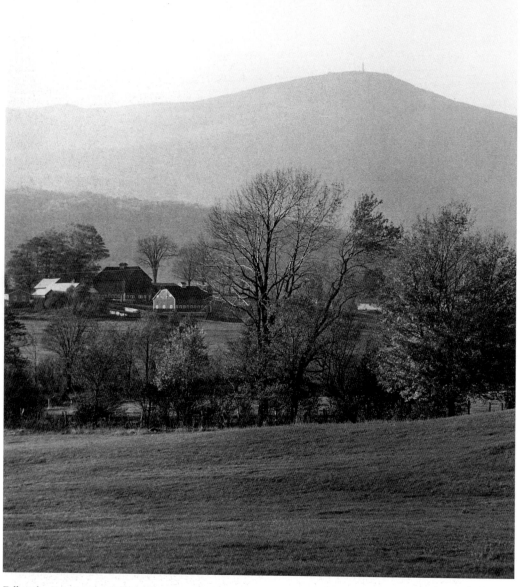

Fall and winter views of the highest mountain in Massachusetts, with an elevation 3,491 feet above sea level. The aerial shot of the Hopper was taken in March 1968.

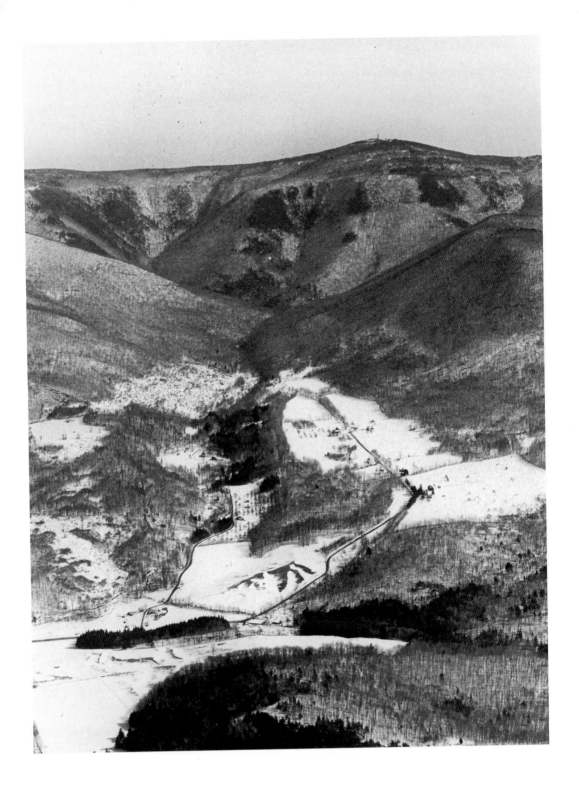

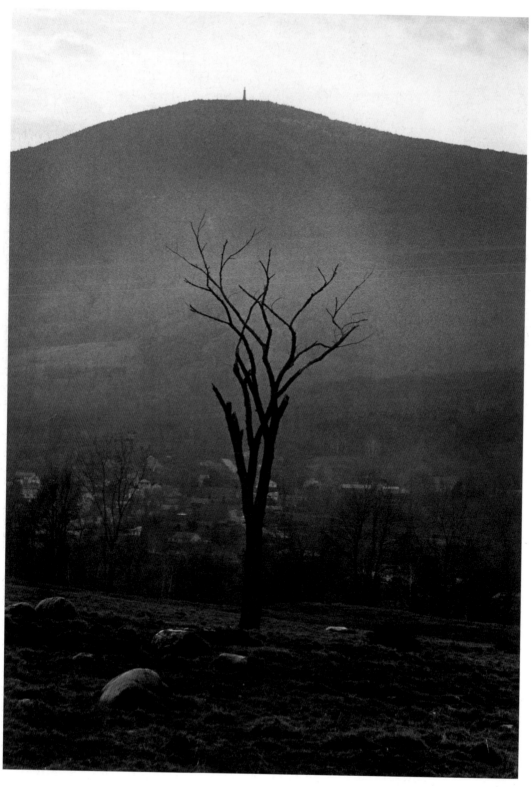

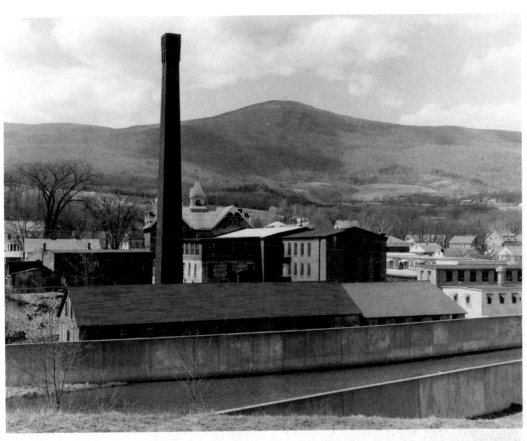

The hand of man is evident in these scenes: an elm skeleton, factories in Adams, and a 1968 look from the old Adams dump.

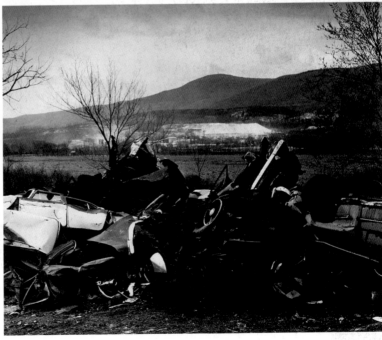

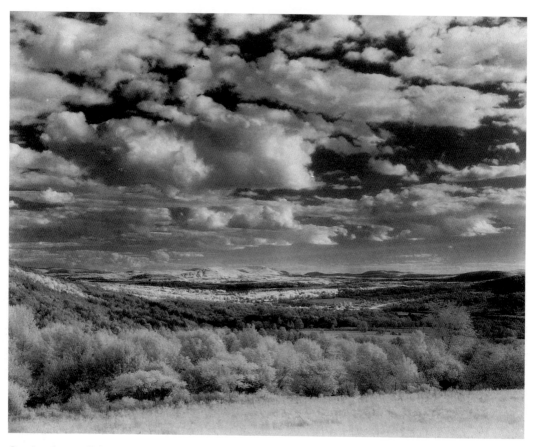

Coming down off the mountain, the scene above is from Rockwell Road; opposite above, a silhouette of the Hopper, and opposite below, the famous hairpin turn above North Adams, a valley away from Greylock.

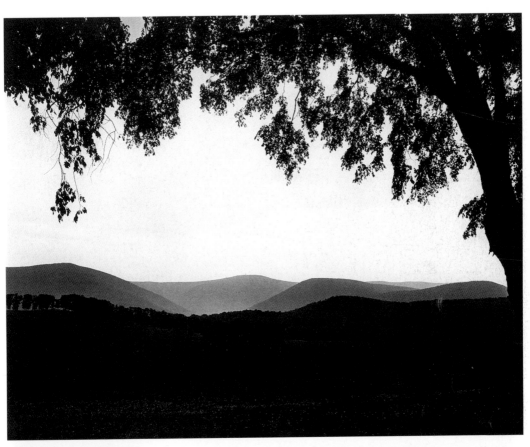

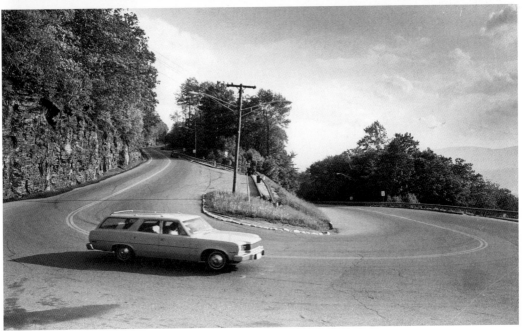

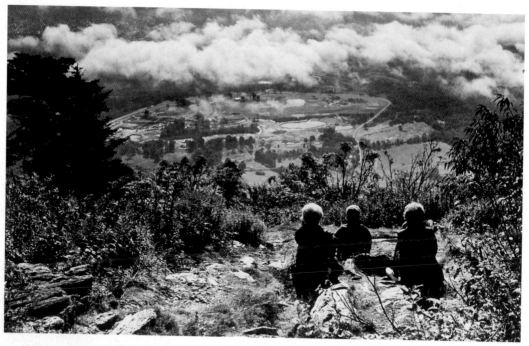

Mount Greylock's memorial tower has been a Berkshire landmark since its completion in 1932. Photographs from the top are often taken from above the clouds.

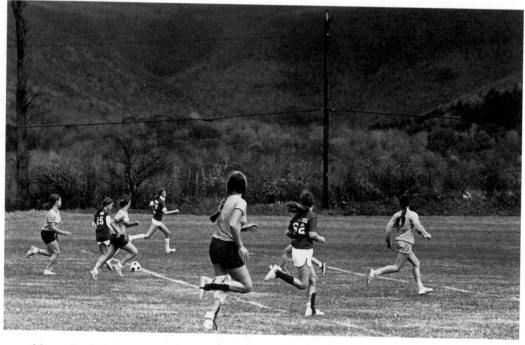

Mount Greylock has always dominated many aspects of life in Berkshire County, including this 1973 soccer game at Mt. Greylock Regional High School in Williamstown. The away team is from Pittsfield High School.

two

Water
(and Some
Ice)

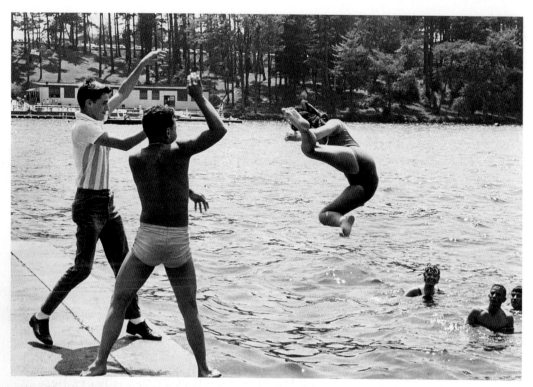

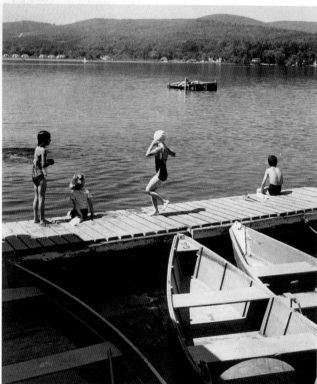

Above: Hijinks at Lake Pontoosuc. The date: July 1962.

Left: Youngsters enjoying the brief summer season, at Lake Buel in Great Barrington

Opposite page: More enjoyment at Lake Pontoosuc in Pittsfield.

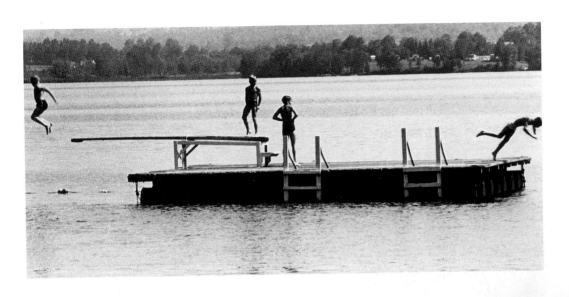

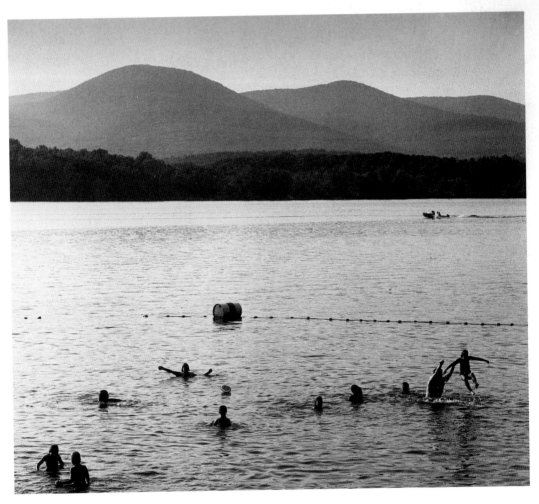

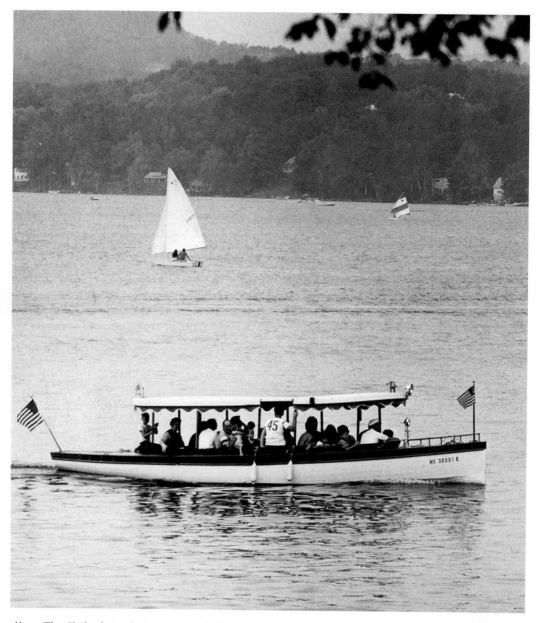

Above: The *Sheila*, shown here in August 1968, offered popular excursions around Pontoosuc a generation ago.

Opposite above: Margaret Lindley Park in Williamstown provides plenty of opportunities for quiet summer fun.

Opposite below: a swimming raft equipped with a bicycle and occupied by two boys provides food for thought in another Pontoosuc scene.

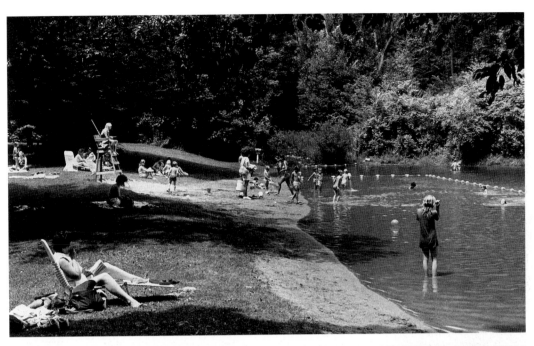

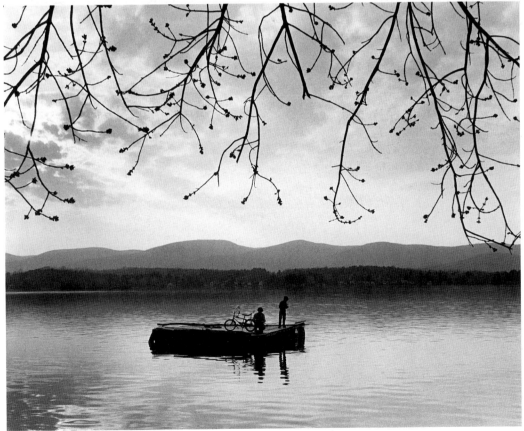

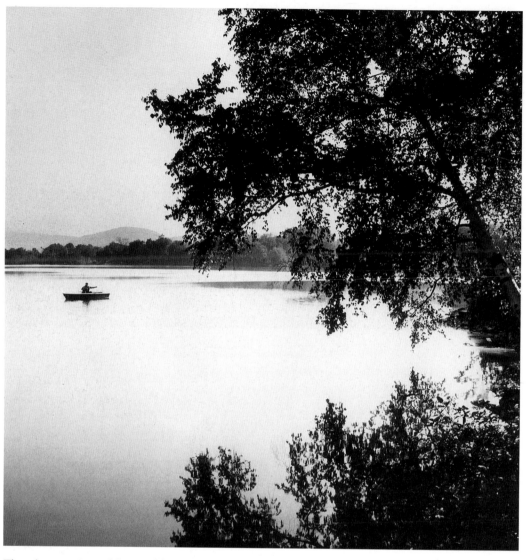

The calm attractions of the art of fishing are manifested in these scenes, both at Lake Pontoosuc.

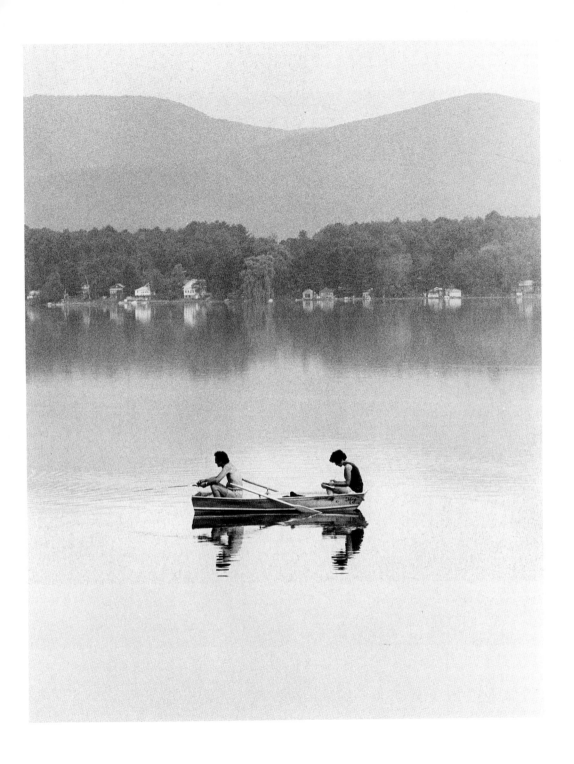

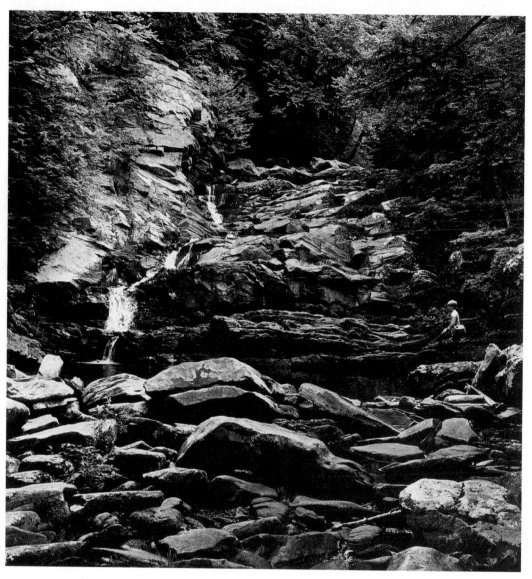

The aesthetics of water falling over rocks gain perspective by having a human figure in each of these photographs. Above, a young angler tests the waters of Wahconah Falls near Dalton; opposite, rock climbing is contemplated at Bash Bish Falls in the town of Mount Washington.

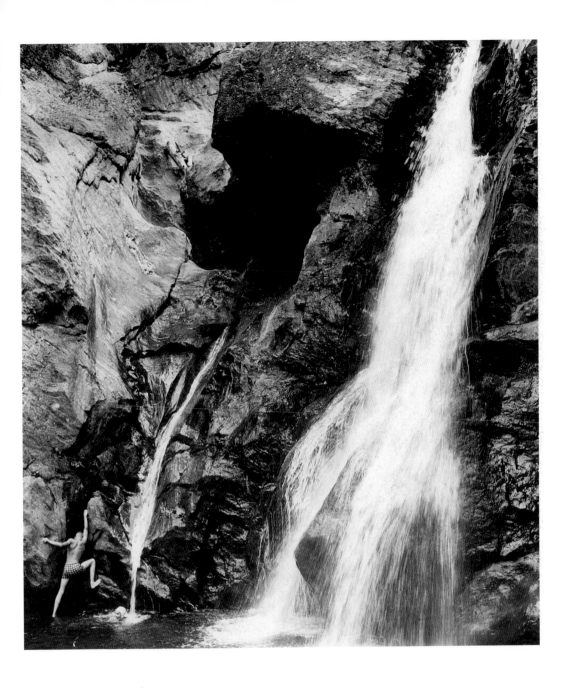

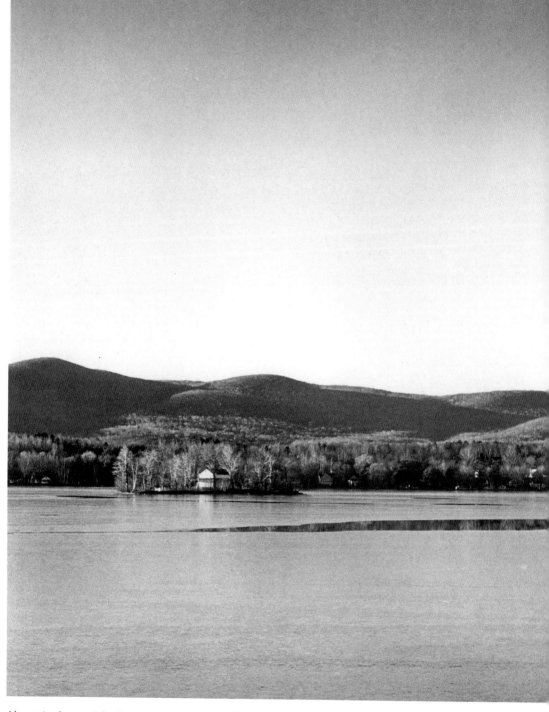

Almost iced over: Lake Pontoosuc was photographed in November 1962. Back in the 1950s Bill and Irene Tague lived in the house seen on Francis Island at left, then owned by the Women's Club of Pittsfield. The house was later destroyed by a fire set by vandals.

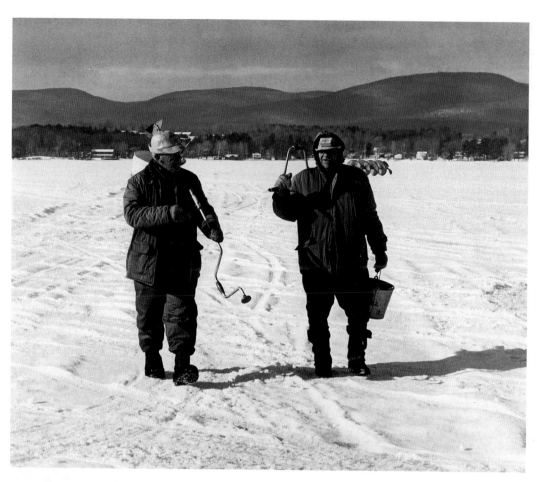

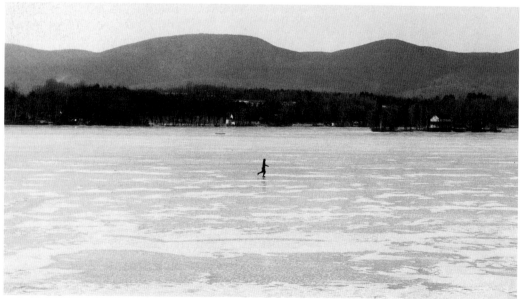

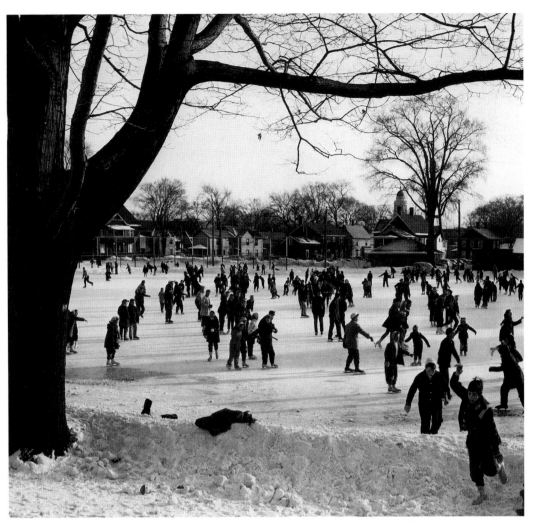

The pleasures of ice are vigorously represented by these photographs.

Opposite above: The two happy hole-drillers were photographed in January 1976, prefatory to some ice fishing.

Opposite below: The lone ice runner is shown in February 1959.

Above: skaters enjoy Pittsfield's "Common" in January 1957.

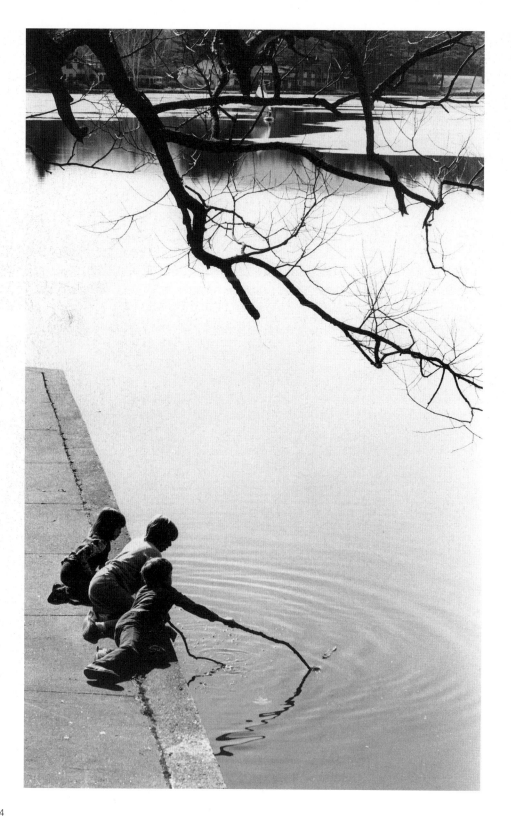

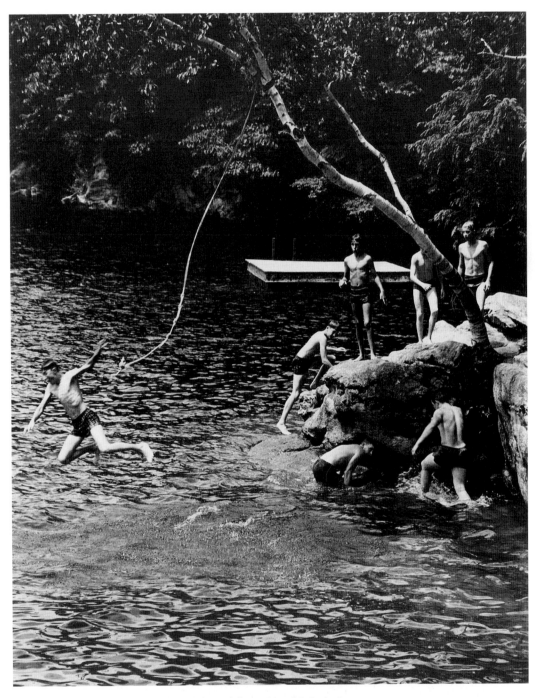

Above: a tree and a rope provide seasonal fun at Laurel Lake in Lee.

Opposite: Children play in the first open water of the season after the ice has broken up on Pontoosuc Lake in April 1978.

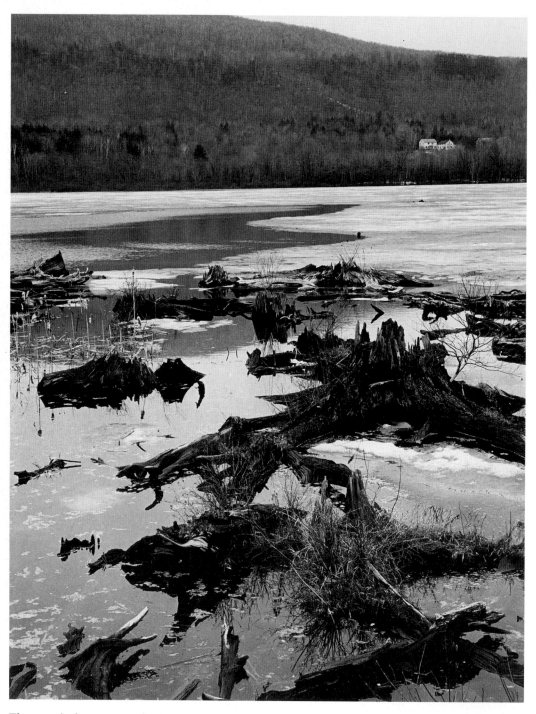

The season's changes are evident among cattails and tree stumps on Hoosac Lake in Cheshire.

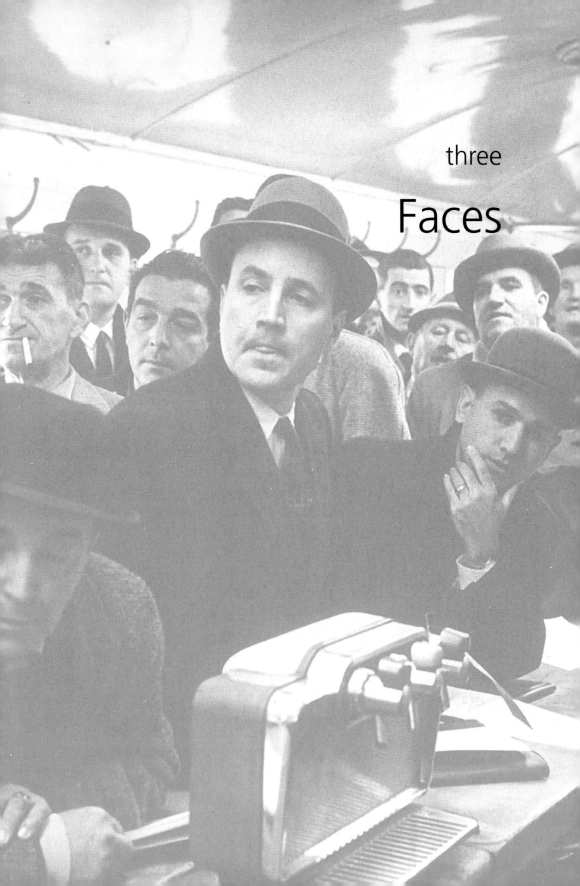

three

Faces

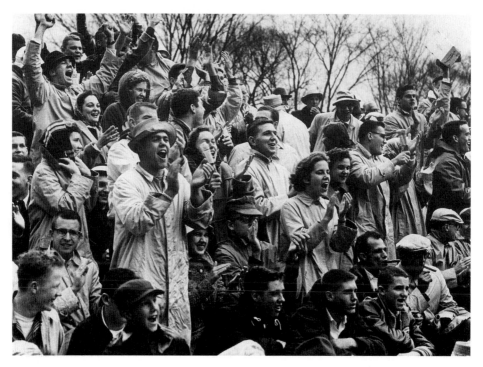

Faces in the stands at a Williams College football game in November 1959. While covering sporting events, Tague often whirled around to capture the fans in addition to the game.

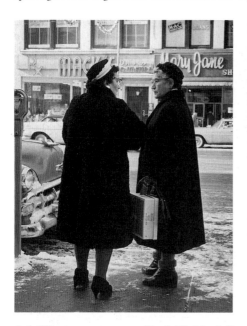

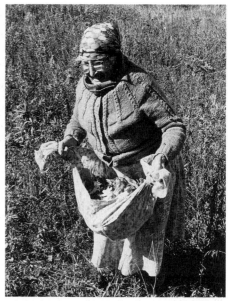

Left: These two women on Pittsfield's North Street in December 1960 were oblivious to the photographer.
Right: a woman identified as Mrs. Serafina Montani of Lee gathers mushrooms in the traditional way.

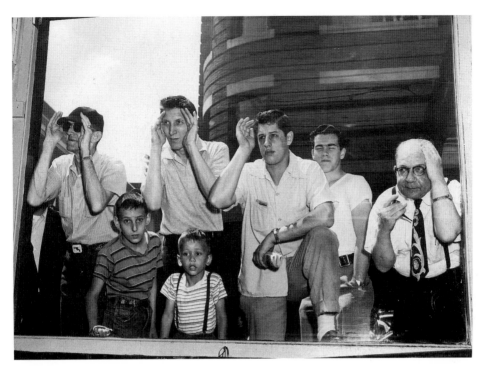

Faces peer through the window to watch the *Berkshire Eagle*'s presses running. Below, older men of Italian descent play a leisurely game of bocce. Both pictures date from the 1950s.

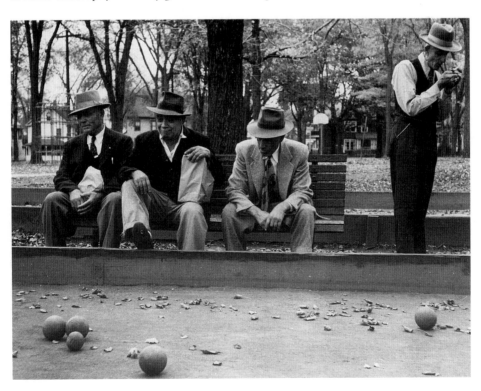

40

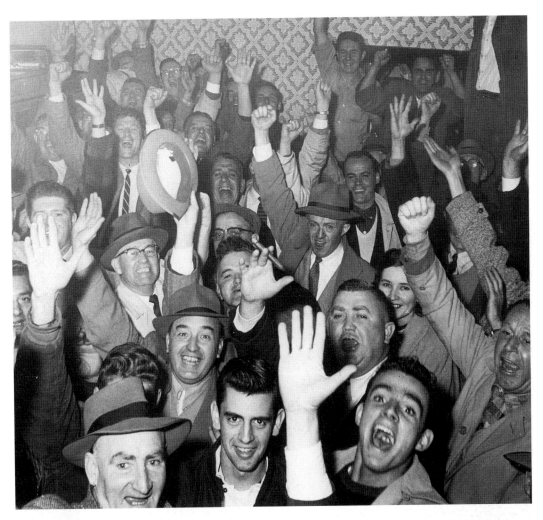

The faces of Pittsfield politics.

Opposite above: impatient mayoral candidates at a forum of the West Pittsfield Civic Society in September 1957; Ray Haughey, at left, was the victor.

Opposite below: a school board (bored?) meeting in September 1964.

Above: the reason for cheering has been lost to time but the date was November 1957.

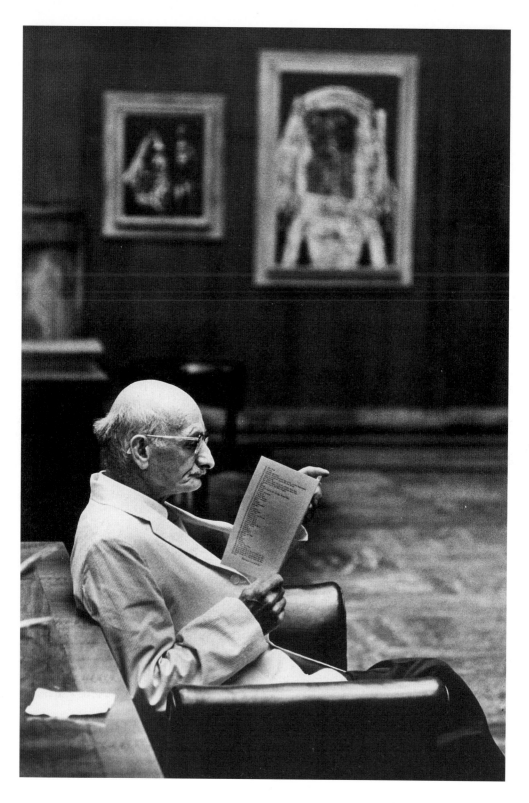

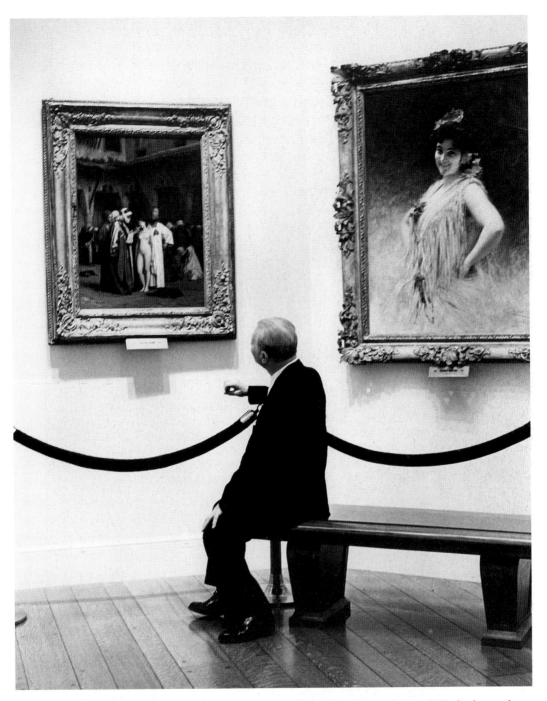

The faces of art. Opposite, an earnest visitor to the Berkshire Museum in August 1959 checks out the catalogue. Above, a patron of the Clark Art Institute in Williamstown in July 1961 seems to have an observer as he studies a famous nude scene.

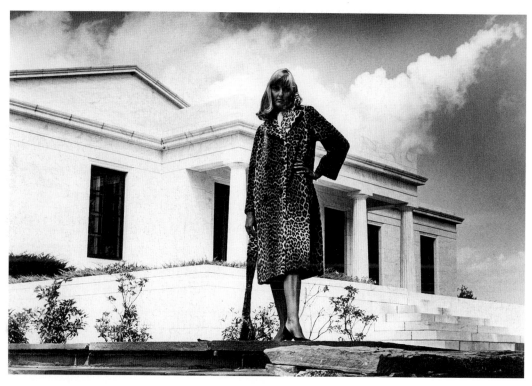

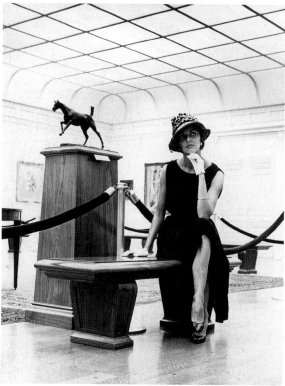

For fashion shots, Tague often used the Clark Art Institute as a background. Both of these scenes were taken there in August 1960; the model for the then-fashionable leopard items was June Rubin.

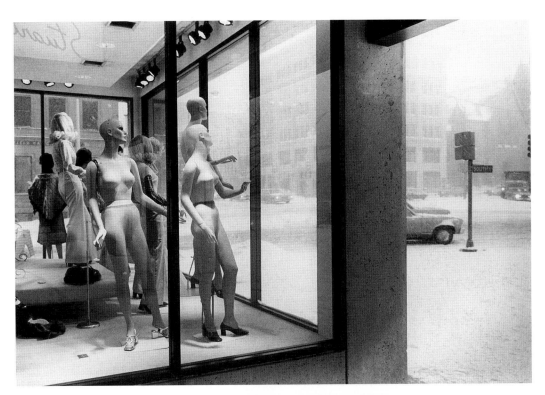

The photographer's sense of humor is evident in these snapshots of unclothed mannikins in a snowstorm and a clown trying not to get a parking ticket along Pittsfield's South Street.

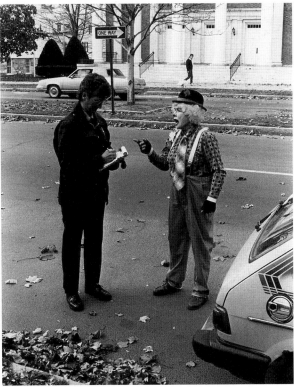

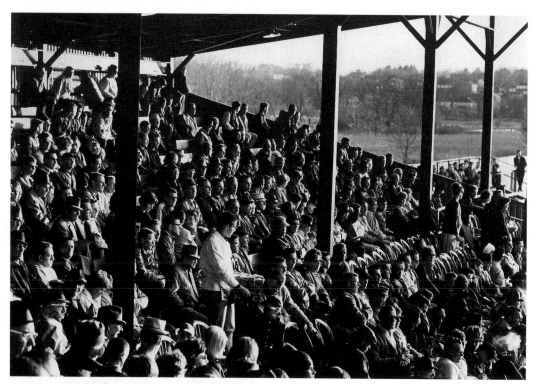

Above: a mostly male crowd enjoys a game at Wahconah Park in Pittsfield in April 1965.

Left: A bocce player in 1957.

Racing spectators at the Great Barrington Fair in the 1950s show varying expressions—and styles of eye wear.

48

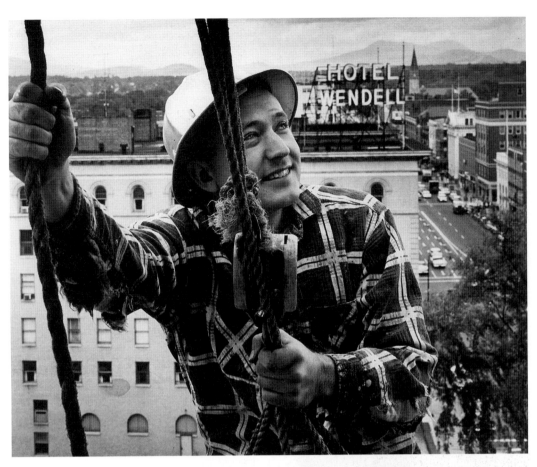

The work ethic of the region is portrayed in these mostly undated scenes. The photograph of the worker clambering up the scaffold, dated September 1962, reveals Pittsfield's former Wendell Hotel, demolished in 1968.

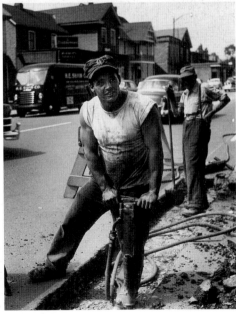

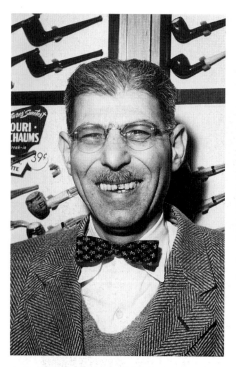

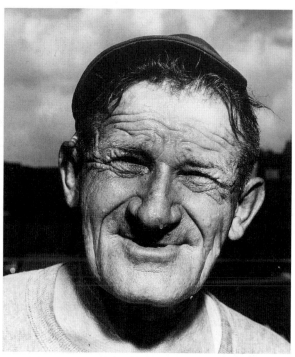

From among these pictures taken in the 1950s of a tobacconist, a roofer, a Hancock selectman, a bingo player, the Hinsdale postmaster (*opposite above*), and Williamstown's police chief (*opposite below*), the only name which survives is that of George Royal, the police chief.

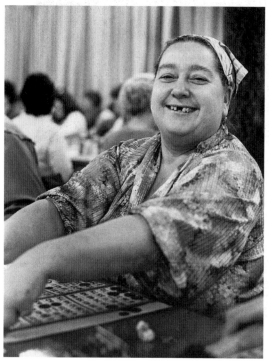

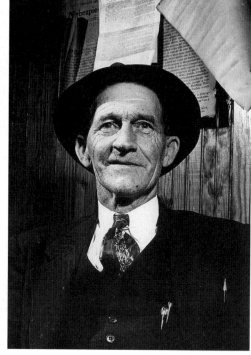

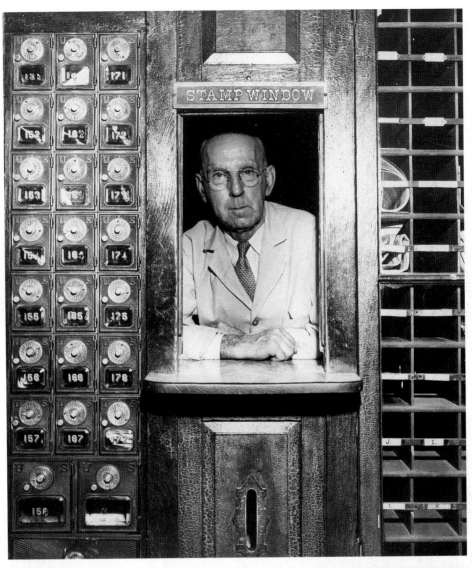

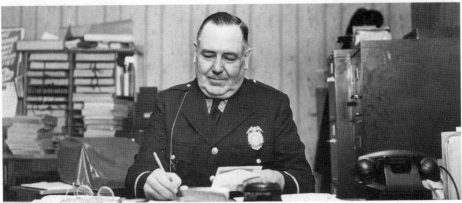

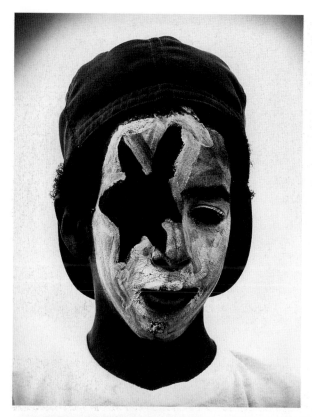

At left is James Robinson, a ninety-one-year-old shoe salesman at the former England Brothers department store in Pittsfield. As for the owners of the faces above: that's anyone's guess.

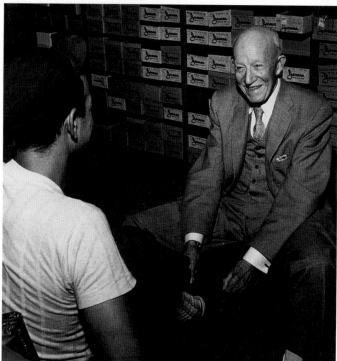

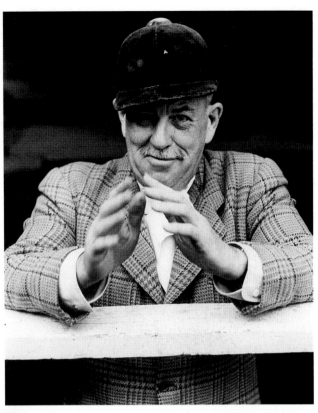

The identities of the faces on this page are well known. Above is Captain Sidney Smith, master of hounds at the Chatham, New York, Hunt Club. On the left is Gertrude Robinson Smith, founder of the Tanglewood concerts.

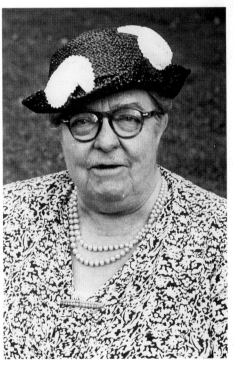

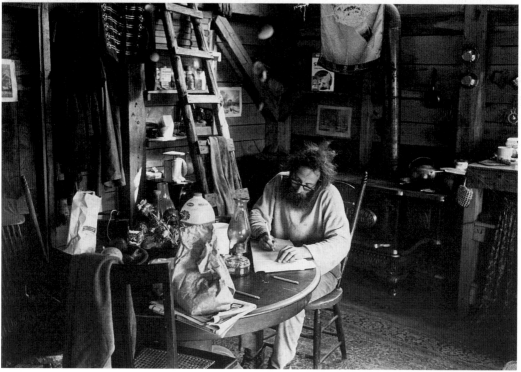

54

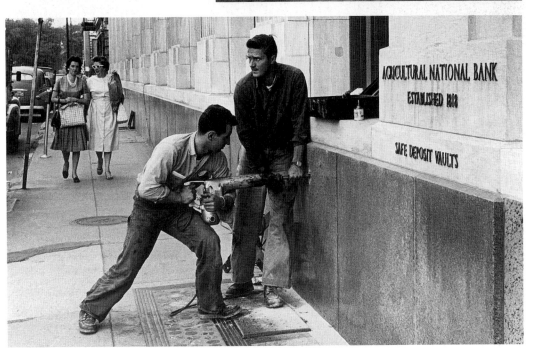

Fads, fashions, and humor are represented here. The 1977 photograph (*opposite below*) documents the trend to back-to-the-landers, heating with wood and growing one's own produce. At right, a clergyman joins a couple at the Stanley Club in 1962 in learning "the twist," the latest dance. The scene below, taken in June 1962, elicits wry comments about breaking into a bank, the anachronistically named Agricultural National, on Pittsfield's North Street.

AGRICULTURAL NATIONAL BANK

ESTABLISHED 1818

SAFE DEPOSIT VAULTS

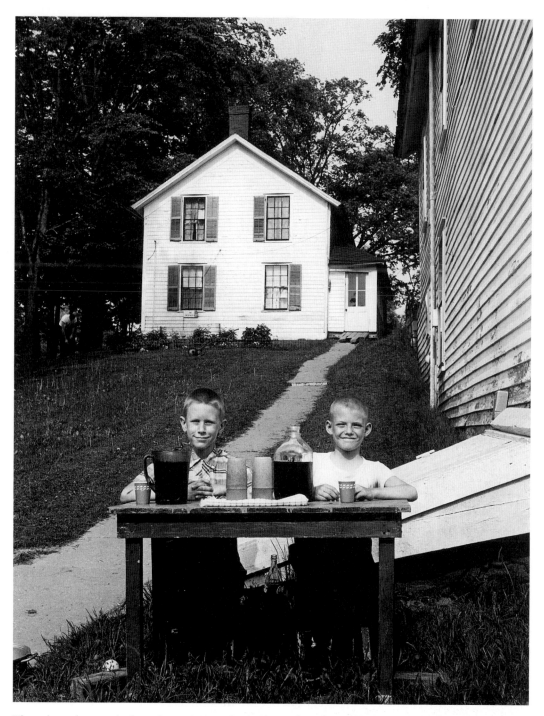

These three photographs from about 1960 involve scenes of childhood. The entrepreneurial boys above offered cool drinks for sale along upper North Street in Pittsfield. The locations of the pictures on the right were not recorded.

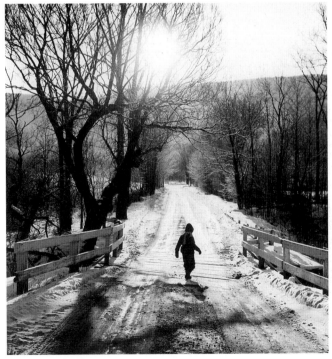

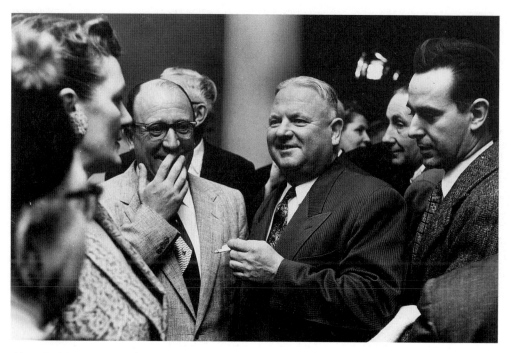

Above: Facial expressions of Pittsfield political figures from the 1950s suggest that someone had just told a bad joke.

Below: President James Phinney Baxter of Williams College addresses a pre-game pep rally in November 1957.

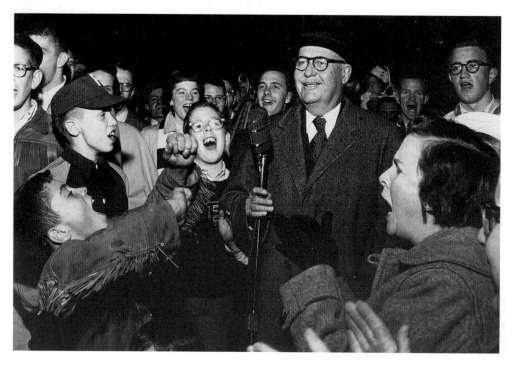

Above: Faces in a barroom all appear earnest, though it is not clear what holds their attention.

Below: Sheriff John Courtney advertises himself at a 1962 election rally.

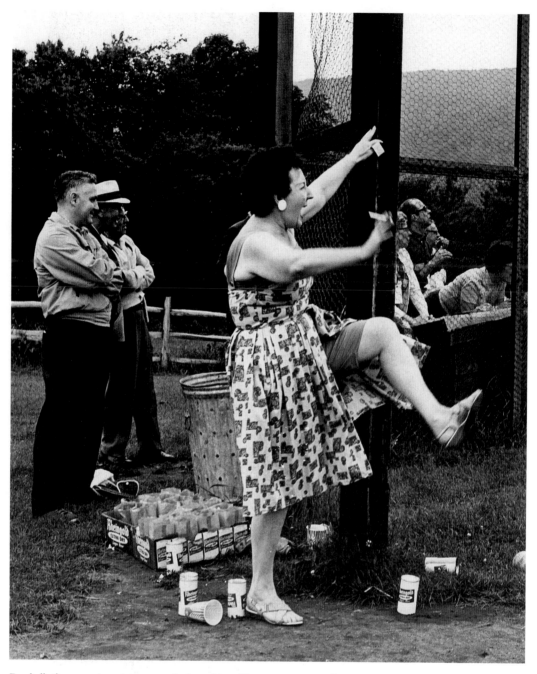

Baseball, the great American game, is the subject. Here, an energetic fan supports her team during an England Brothers picnic game at the Jug End in June 1961.

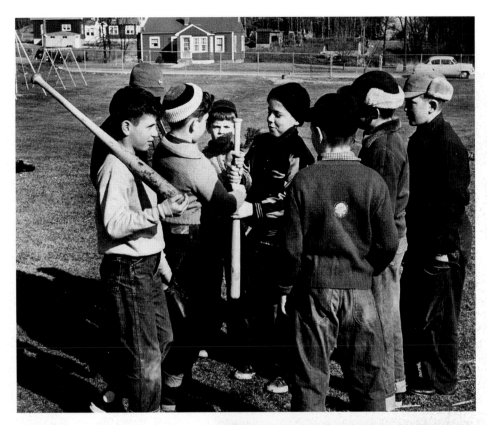

Above: The traditional way to make a decision is followed by these Pittsfield lads in 1979.

Below: A coed softball game takes place near the woods in Stockbridge, in an image dating from May 1974.

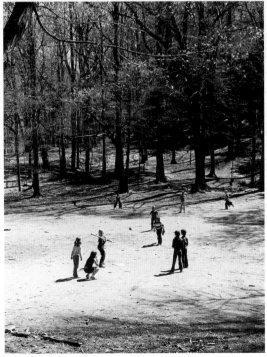

Lotsa luck, guys.

Prominent Residents and Visitors

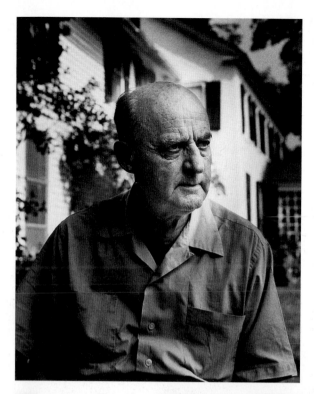

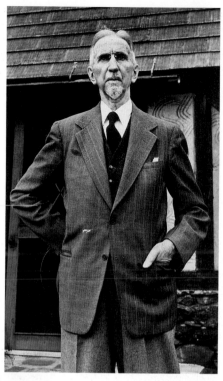

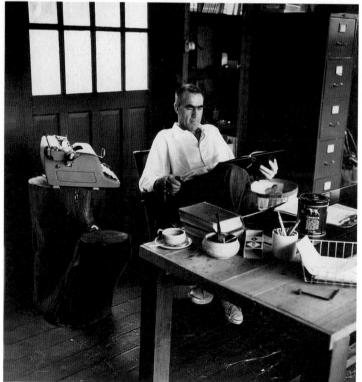

Prominent residents of the Berkshires have included theologian Reinhold Niebuhr (*above left*), clergyman Anson Phelps Stokes (*above*), and playwright William Gibson (*left*). These photographs were all taken in the late 1950s.

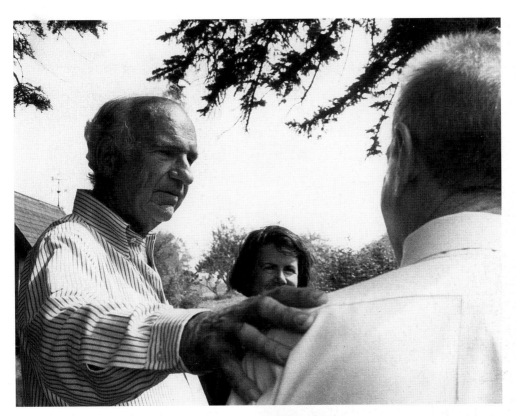

Historian James McGregor Burns (at left in both of these photographs) was a professor at Williams College. In 1958 he challenged Silvio O. Conte, then a state senator, for election to Congress. Conte (at right, standing) won that election as well as the next fifteen. Burns remained at Williams and won a Pulitzer Prize in 1971 for his biography of Franklin D. Roosevelt. Tague took the above picture of him for Eagle Eye in August 1988.

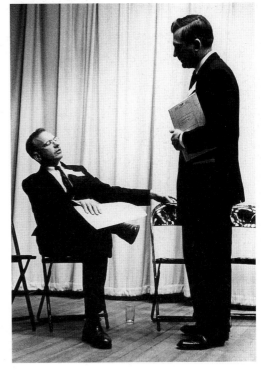

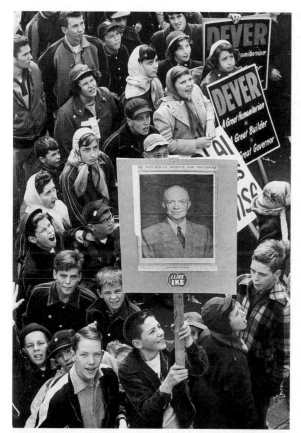

A sort of Eisenhower craze swept Berkshire County in 1956 when "Ike" campaigned for reelection in Pittsfield. The President is accompanied in the photograph below by politicians Silvio O. Conte (left) and Henry Cabot Lodge. At left, these young faces from the 1950s help to define the term "adulation."

Opposite above: The Ike mania is demonstrated by Morris Ziskind of Pittsfield.

Opposite below: U.S. Senator Leverett Saltonstall confers with Governor Christian Herter.

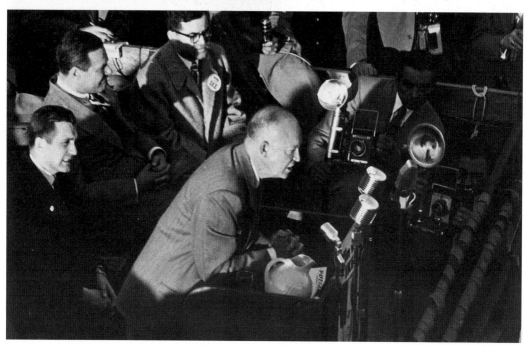

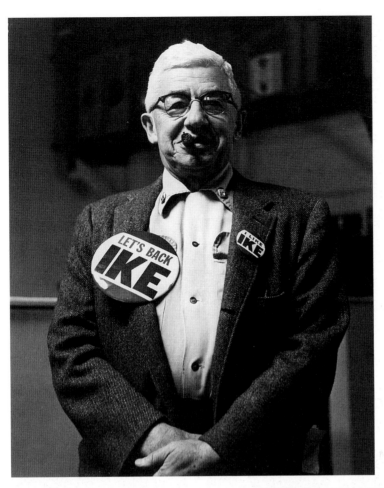

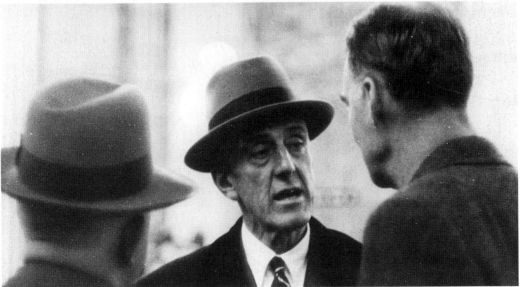

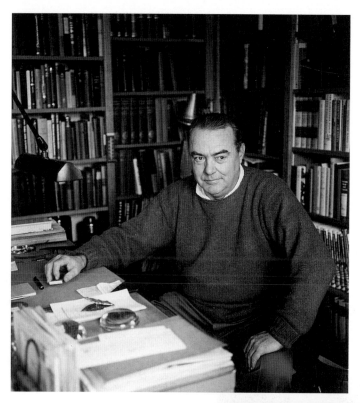

Famous names in the Berkshires have included James Gould Cozzens (*left*) shown in 1961 at his desk at "Shadow Brook" in Williamstown; and playwright Tennessee Williams (*below*) attending a 1979 Williamstown production of his *Camino Real*. Both were Pulitzer winners, Williams for *A Streetcar Named Desire* and *Cat on a Hot Tin Roof*, and Cozzens for his fiction *Guard of Honor*. *Opposite above:* Primitive artist Anna Mary "Grandma" Moses, a resident of nearby Eagle Bridge, New York, is shown in 1953 at the Arnold Print Works in Adams, where one of her images was being applied to textile. *Opposite center:* Francine Clark chats with an admirer at the formal opening of the Sterling and Francine Clark Art Institute on May 17, 1955. *Opposite below:* Economist J.K. Galbraith is shown at a Williams College function.

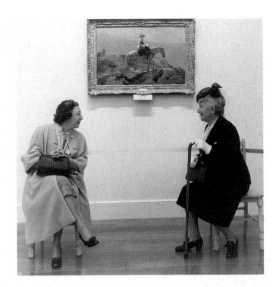

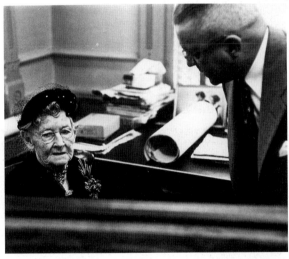

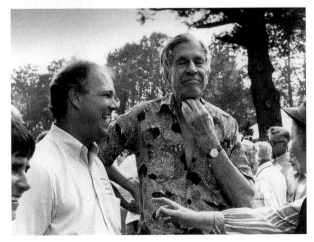

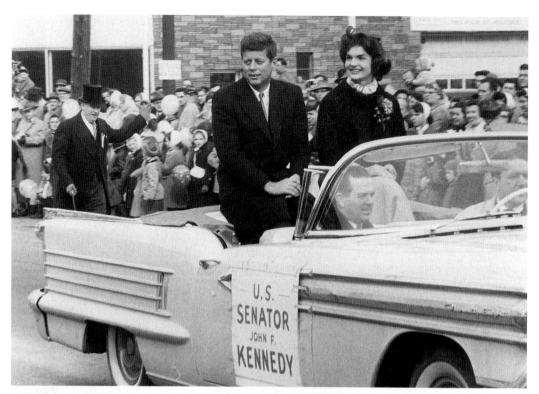

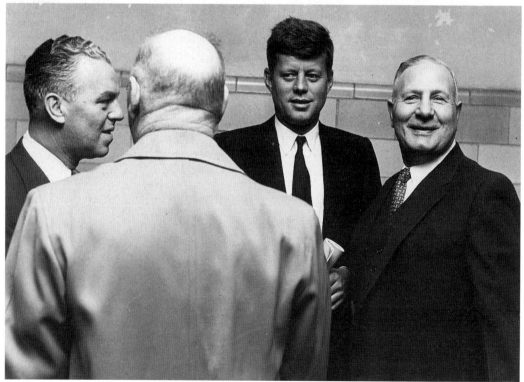

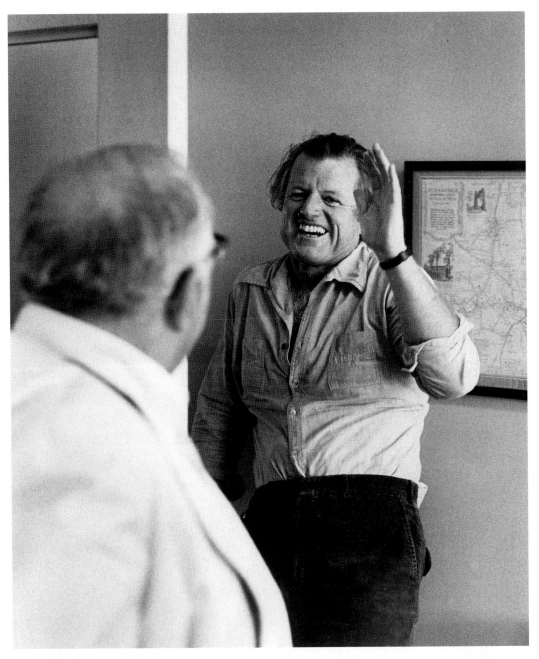

Opposite above: U.S. Senator John F. Kennedy and his wife Jacqueline greet crowds at a St. Patrick's Day parade in Holyoke on March 16, 1958.

Opposite below: Kennedy was photographed in May 1956 with Al Morano (right), a retired Pittsfield policeman, at a police communion breakfast; at left is editor John G.W. Mahanna of the *Berkshire Eagle*.

Above: a political generation later, Senator Ted Kennedy shares a joke with Abe Michaelson, the *Eagle*'s political writer.

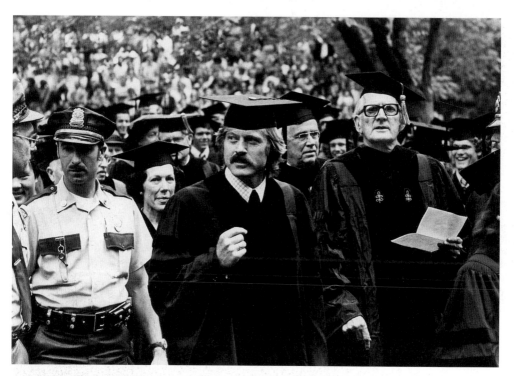

Faces in the crowd at Williams College commencements: above, actor Robert Redford gets an honorary degree in 1977; below, Spiro Agnew, the former Vice-President, in 1980.

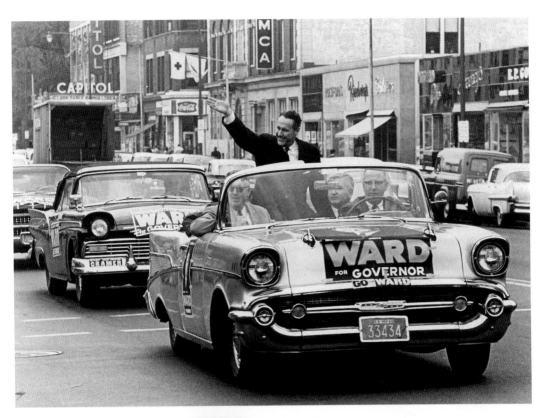

Above: A long-forgotten
candidate for governor
waves to an apparently
non-existent crowd along
North Street in Pittsfield in
September 1960.

Right: Governor Endicott
Peabody (right) and
Dr. Glenn T. Seaborg,
chairman of the U.S.
Atomic Energy
Commission, share the
stage on April 2, 1963, at
the 100th anniversary of
the University of
Massachusetts.

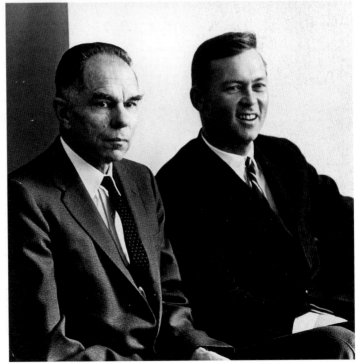

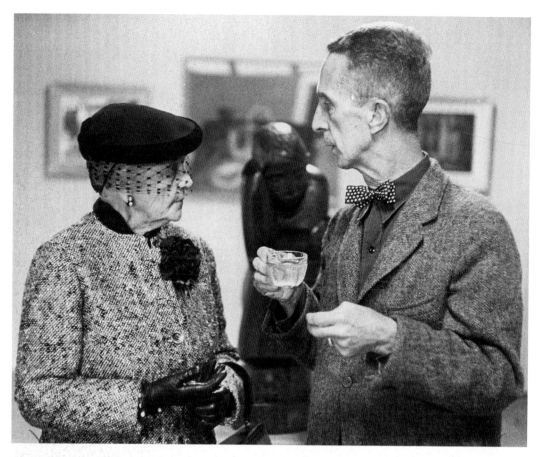

Above: Illustrator Norman Rockwell appears to undergo the scrutiny of a fellow guest at the opening of a show at the Peggy Best Gallery in Stockbridge. The date was probably in the late 1950s. Rockwell moved to Stockbridge from Vermont in 1953 and lived there until his death in 1978.

Opposite: Charles Munch, music director of the Boston Symphony Orchestra, which summers at Tanglewood in Lenox, seems certain to make the putt in this photograph taken in August 1957.

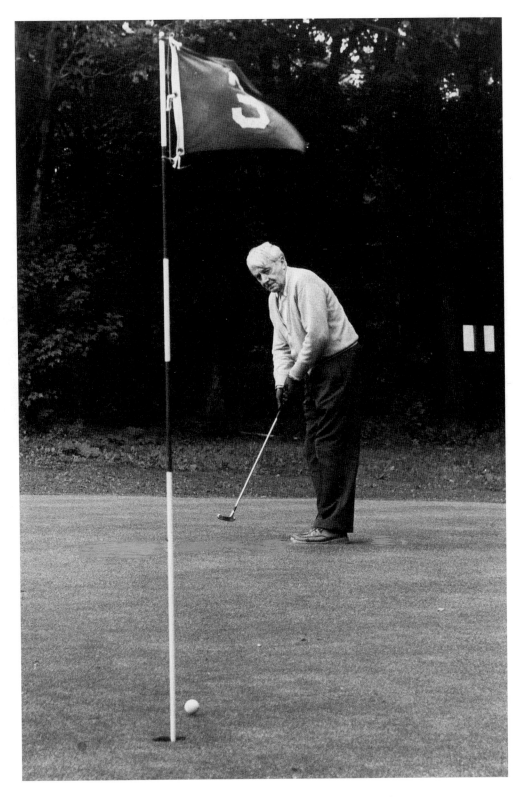

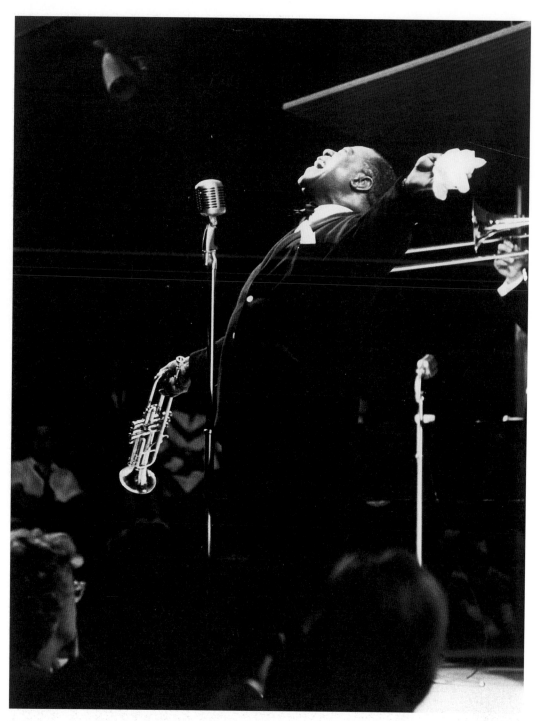

Louis Armstrong was photographed in the Music Barn in Lenox in July 1962.

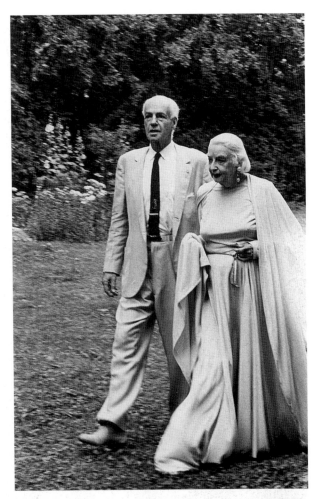

Jacob's Pillow founder Ted Shawn and his wife, dancer Ruth St. Dennis, made a garden-side entrance in August 1964 and then held a back-porch news conference.

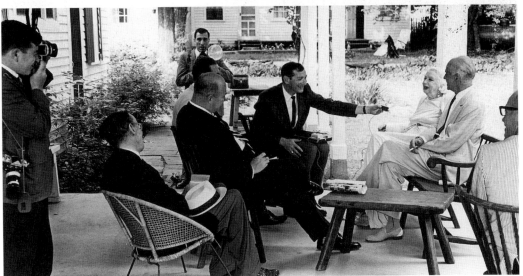

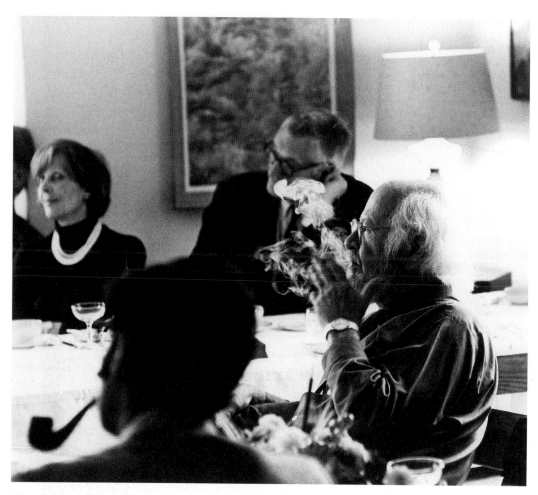

Wreathed in smoke, Berkshire County author William L. Shirer (right) attends a September 1972 political rally for George McGovern, Democratic candidate for president. In the background is Lawrence K. "Pete" Miller, publisher of the *Berkshire Eagle*.

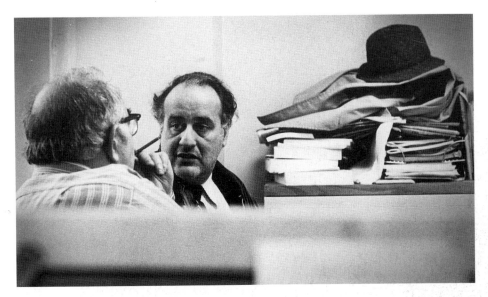

Above: Serious politics is the subject between Peter Arlos, longtime Berkshire County political figure, and the *Eagle*'s Abe Michaelson in January 1980. *Below:* U.S. Senator Edward Brooke emerges from his car for an appearance at Williams College in September 1966.

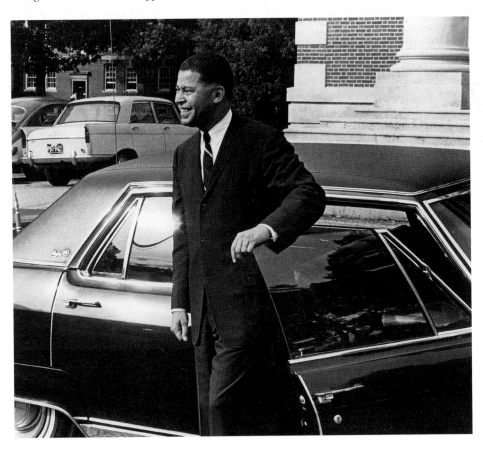

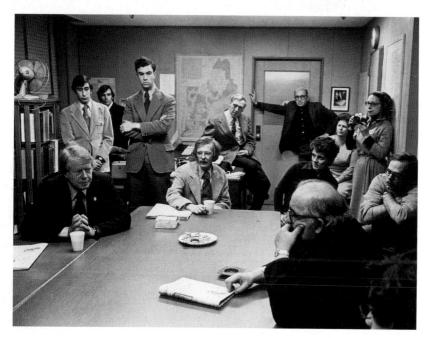

Democratic presidential candidate Jimmy Carter, the former governor of Georgia, visits the *Eagle* office in January 1976.

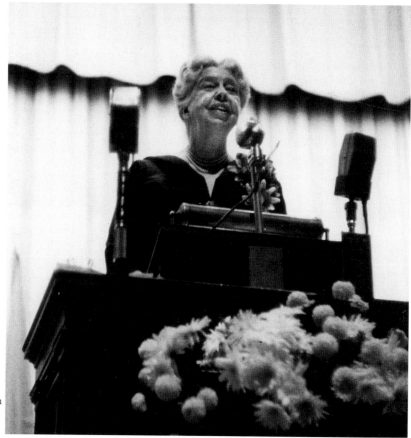

Eleanor Roosevelt speaks at Pittsfield High School in the early 1950s.

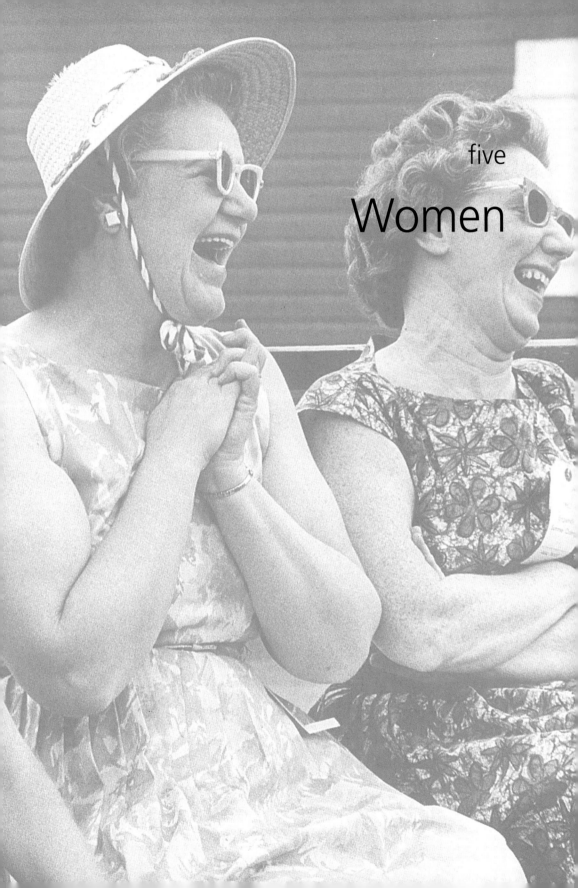

five

Women

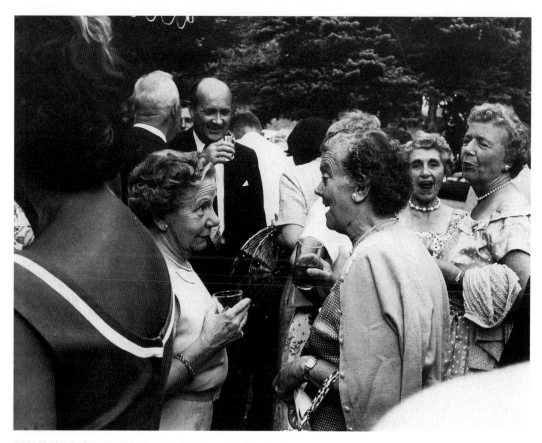

This occasion and the names were not recorded, but the date was August 1958, and the expressions remain unforgettable.

Entertainment was provided at an England Brothers picnic at the Jug End in July 1963. On the next page, no details were kept of the scene at the top; the couple below were photographed at the Williamstown Summer Theater Festival's traditional opening party in July 1960.

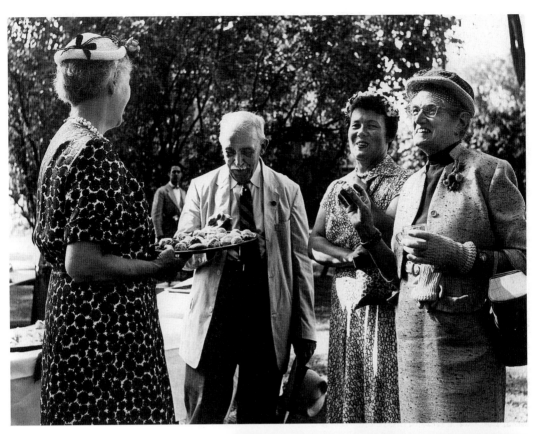

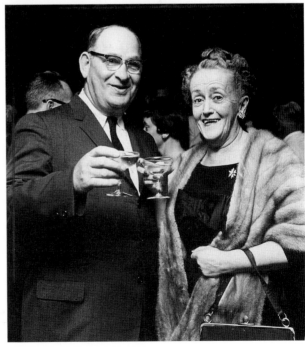

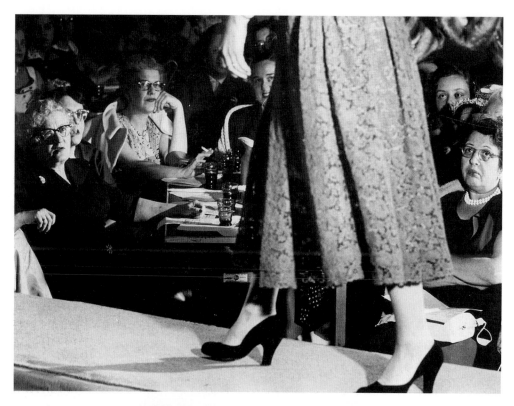

Above: responses vary to
fashions at a show at
England Brothers.

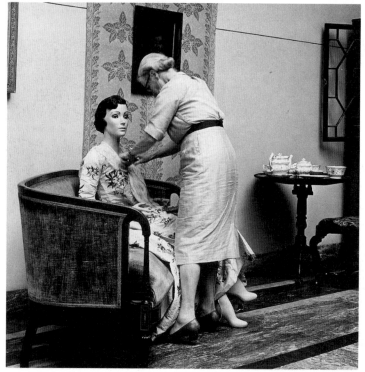

Left: Kay Annin (a
Berkshire Eagle columnist)
dresses a model for a 1961
Berkshire Bicentennial
exhibit at the Berkshire
Museum.

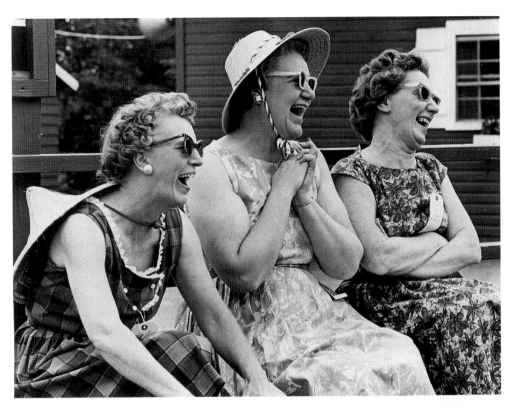

Another mirthful scene was captured (*above*) at an England Brothers picnic in 1963. *Below:* a parading chorus from the Lenox Kiwanis does just what the sign promises. The date: July 1979.

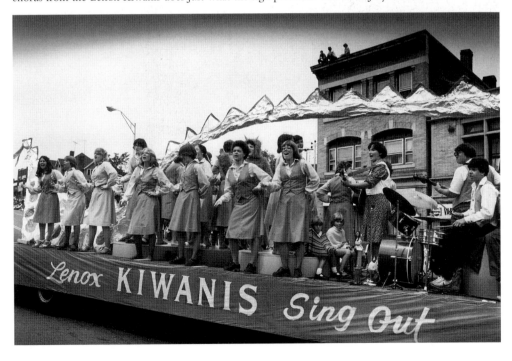

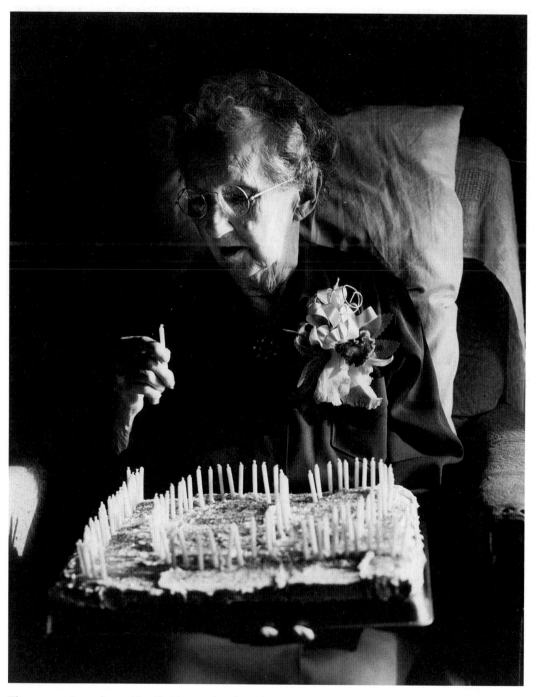

These two poignant but unidentified images date from the 1950s. The cake above has "100" on it, spelled out in candles.

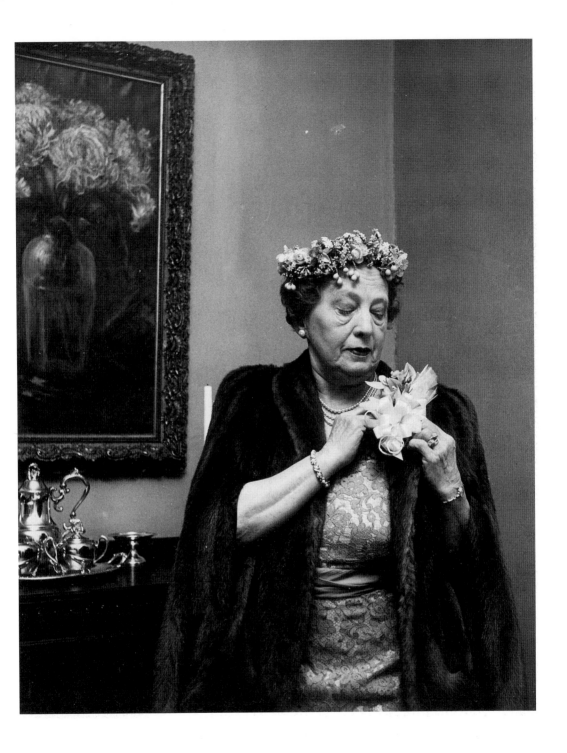

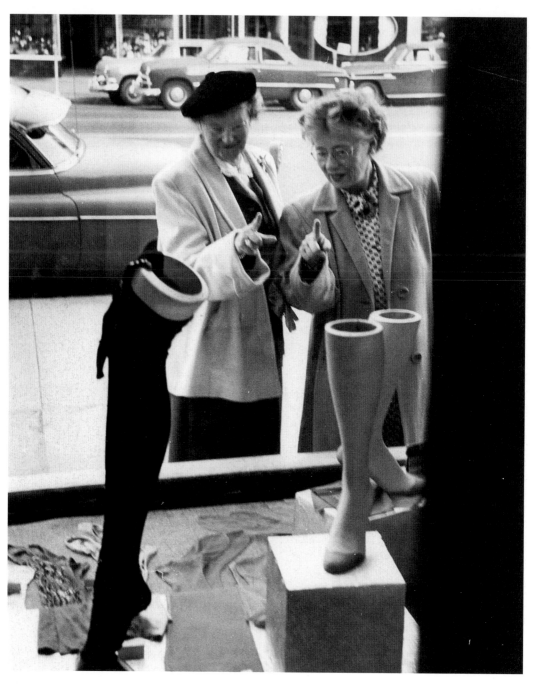

These are two more scenes from the 1950s, both probably taken surreptitiously.

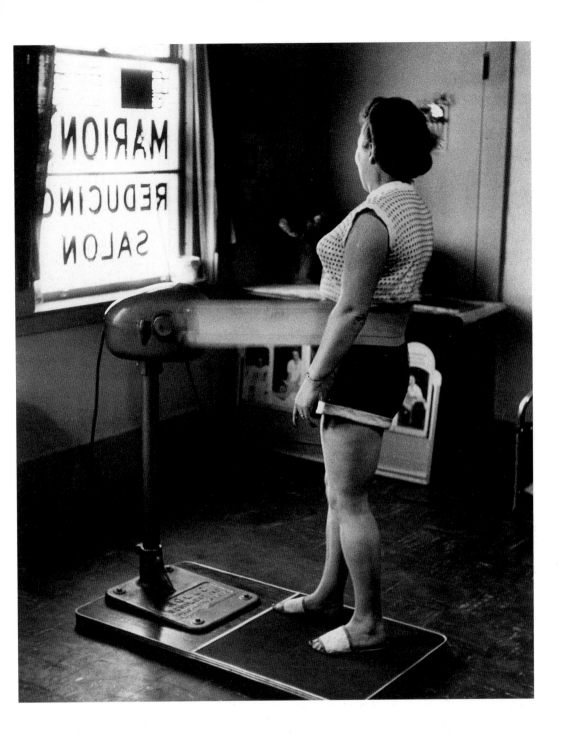

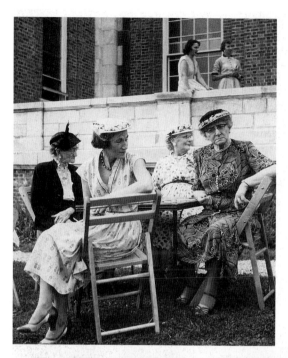

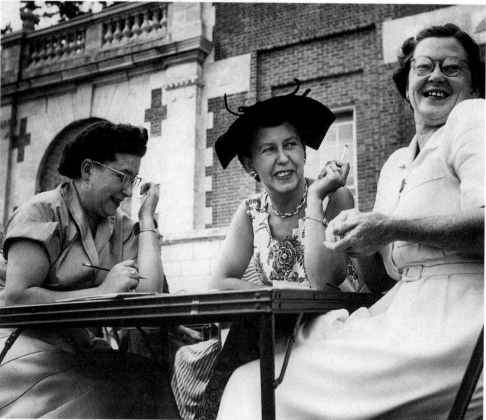

90

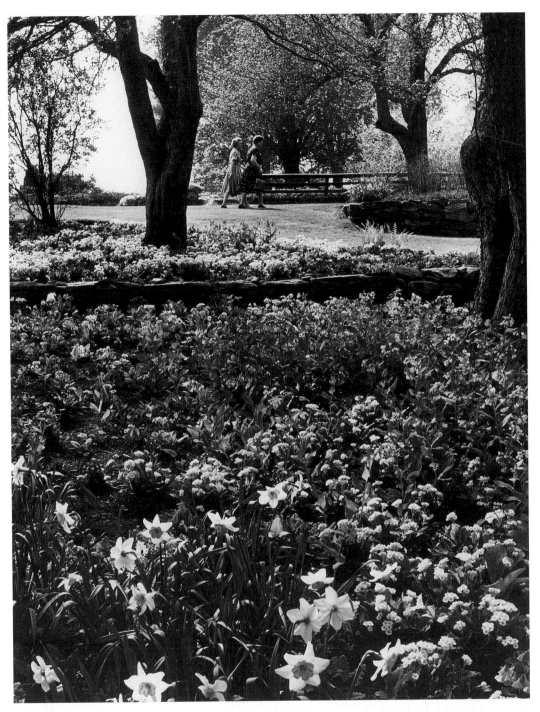

The photographs opposite, both evidently taken at the same event, might be described as from the millinery era. Above, it's spring at the Berkshire Garden Center in Stockbridge in May 1962.

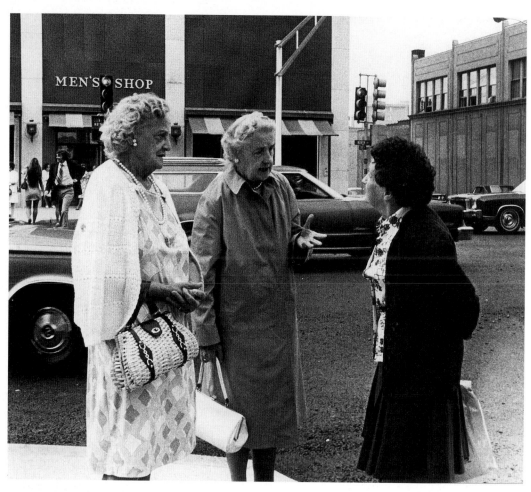

This conversation along Pittsfield's North Street was photographed in September 1974.

Those Cultural Berkshires

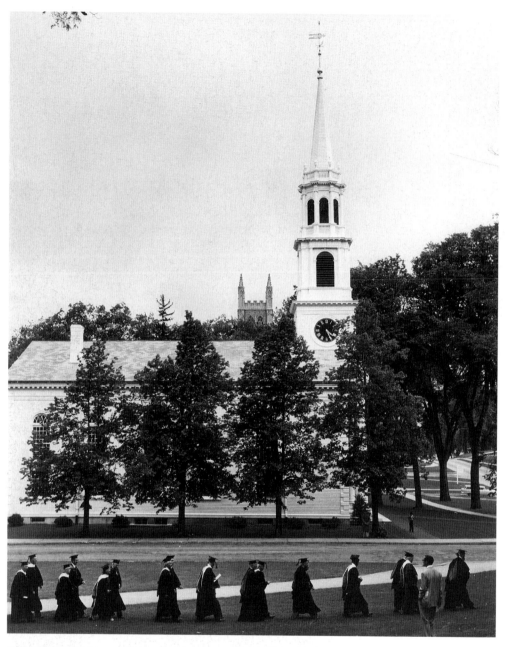

Bill Tague probably covered more commencements at Williams College than any other single photographer. These are ceremonies full of pageantry, pomp, and joy.

Above: the academic procession of 1958.

Opposite above: The 1984 50th reunion of the Class of 1934, led by a Ford of the appropriate year.

Opposite below: The 1980 convocation headed by High Sheriff of Berkshire County Carmen Massimiano.

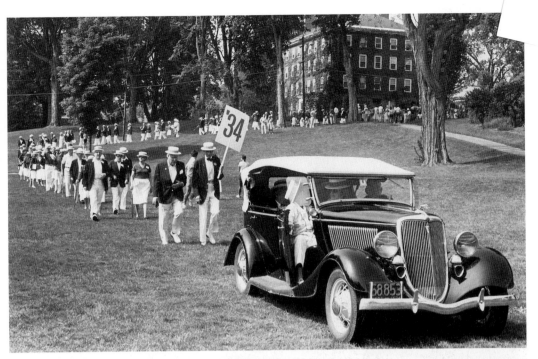

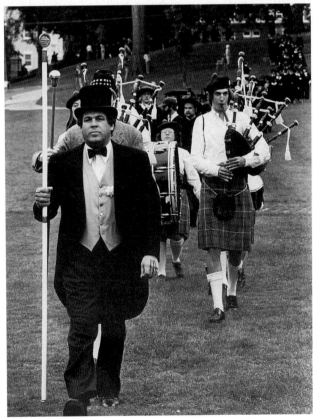

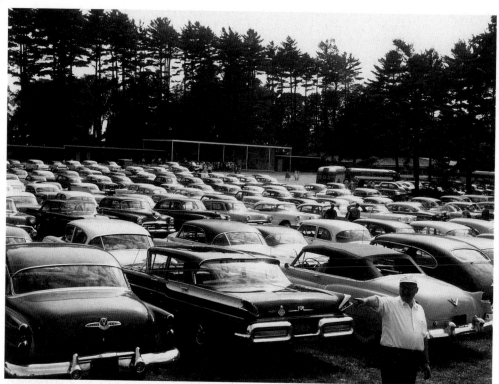

Tanglewood, the premiere summer attraction of the Berkshires, with its Boston Symphony Orchestra concerts, has its own rituals for arrival and entry. Both pictures on this page were taken in 1957, as the cars, which seem antique to us now, demonstrate. *Left:* Necktied patrons carry the picnic ingredients. *Opposite:* A cellist and friend cross the lawn in the summer of 1960.

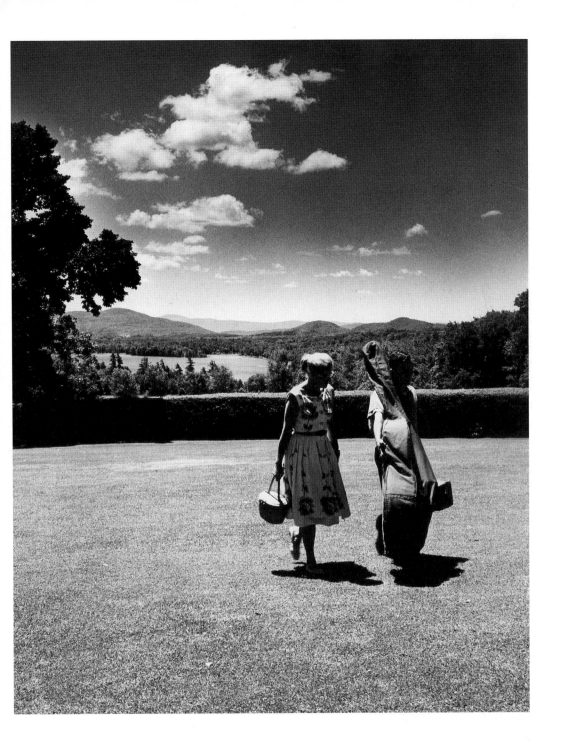

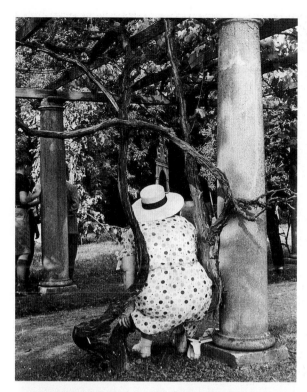

"Any seat in a pinch," even a grapevine, sometimes must suffice at Tanglewood. On occasion, as the couple below found out, an ample square footage of grass can be located. The closer one gets to the music shed, the more crowded the quarters tend to become. *Opposite above:* One patron in 1985 seems to relish facing the wrong way.

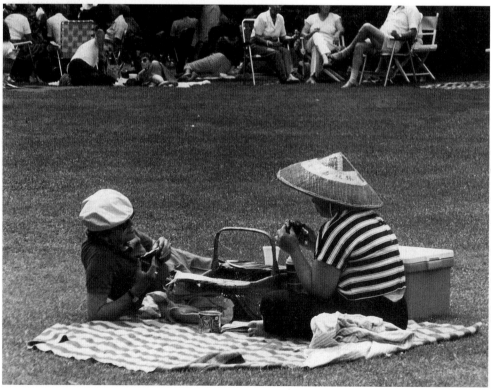

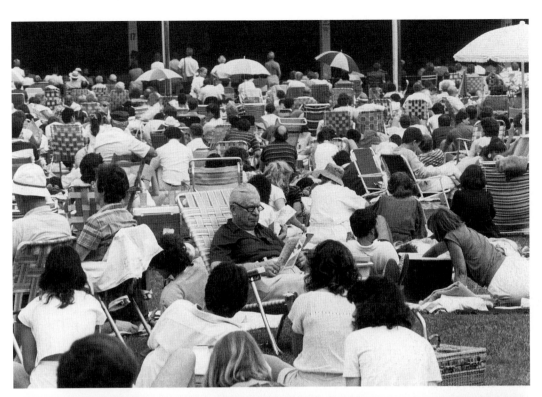

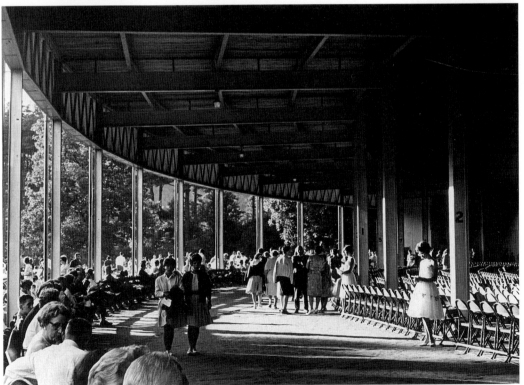

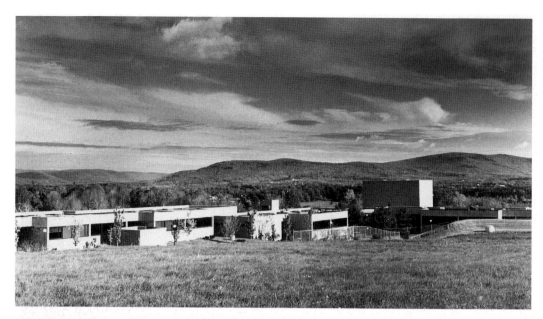

Berkshire Community College (*above*) sprang up on this spacious campus west of Pittsfield during the 1960s. *Below:* A cultural institution for a time was the Fokine Ballet Camp in Lenox, shown here in 1961.

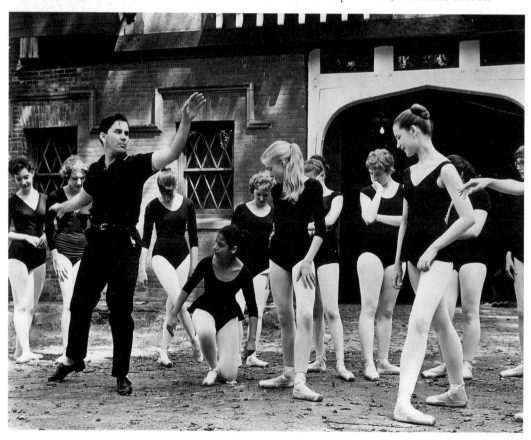

The Mission House in Stockbridge is almost the oldest standing structure in Berkshire County. It was built in 1739, and restored and opened to the public in 1929. This photograph was taken in September 1958.

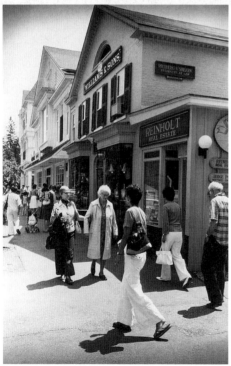

Stockbridge exudes unique charms summer and winter. *Above:* Warm-weather visitors gather outside the famed Red Lion Inn. *Opposite:* This rare diversity of architecture was once captured by a famous Norman Rockwell panorama. Rockwell himself had a studio beyond the large second-story window in the gabled building at left.

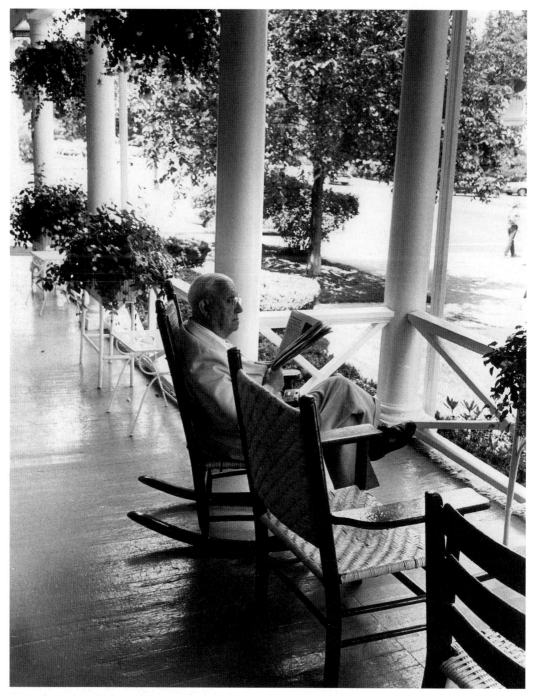

Above: A state of serenity appears to have been achieved in this July 1979 scene on the Red Lion's porch.

Opposite: Visitors in Stockbridge in 1962 dine underneath years of posters and mementoes of Berkshire Playhouse performances.

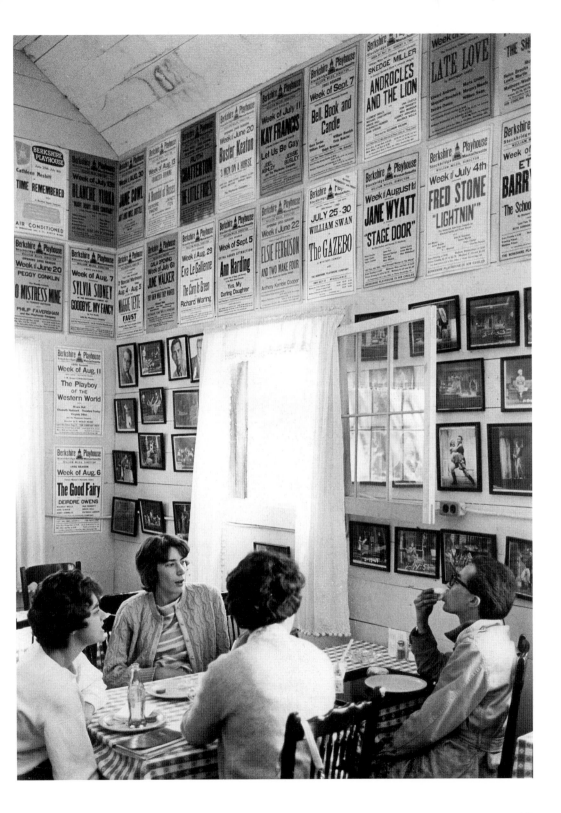

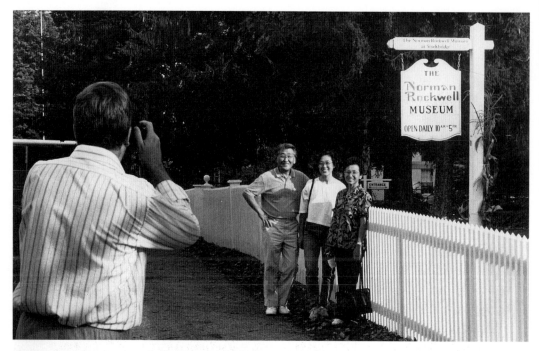

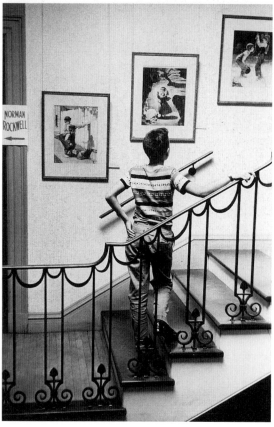

Remembering Norman Rockwell has become a virtual industry in Stockbridge, and a small museum was operated for many years in the village. Tague died shortly after he took this picture in October 1990 of Japanese tourists posing for a snapshot, and he did not live to record the new Rockwell museum a few miles away, which has proven extremely popular. The photograph of the football player, coach, and trainer was a scene carefully posed by Rockwell in 1966 and photographed by Tague for a Rockwell illustration. The model was actually Williams College coach Frank Navarro.

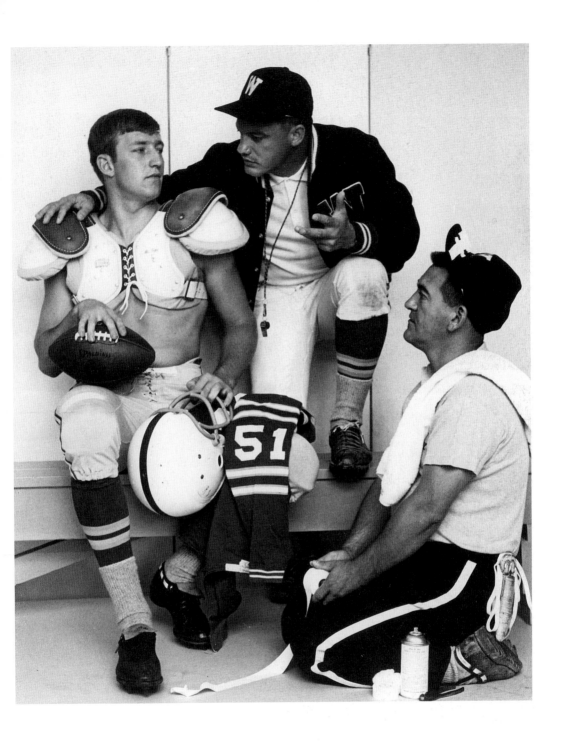

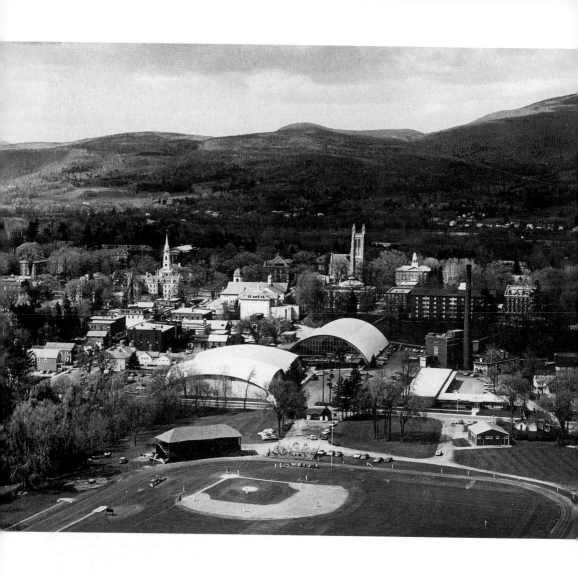

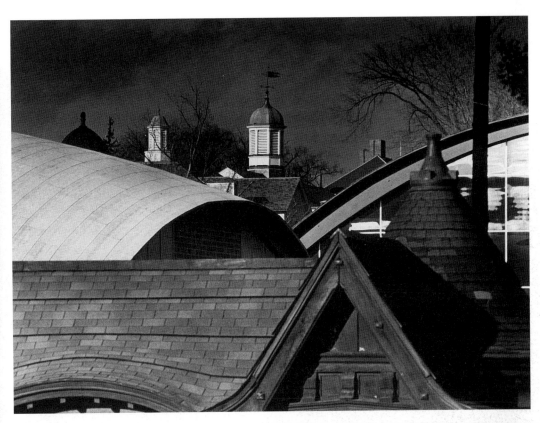

Above: An imaginative view of some Williams College roof lines in 1980.

Right: Snowstorm football at Williams in January 1984.

Opposite: The aerial view of the Williams campus accentuates its relationship to the surrounding Berkshire hills; the photograph is undated but was probably taken in the 1960s.

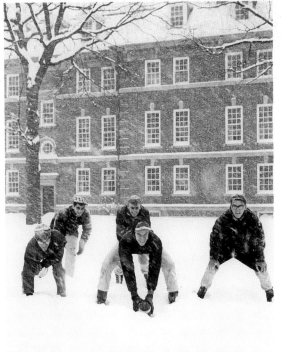

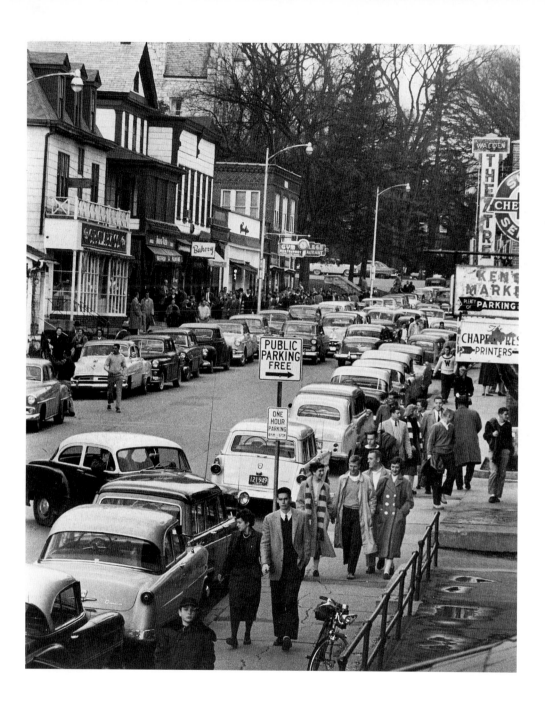

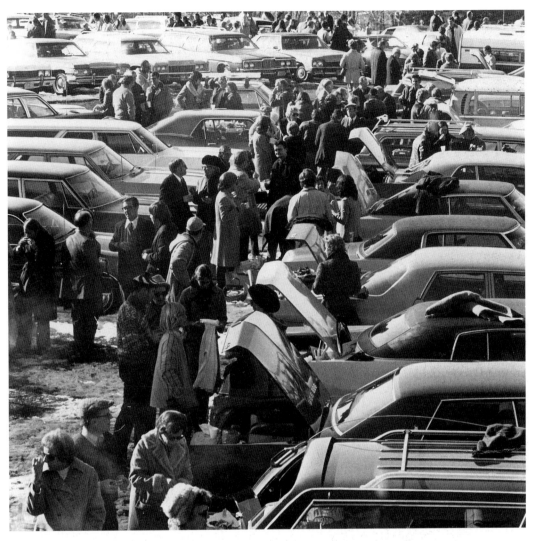

The above scene in Amherst during a Williams football weekend gives new meaning to the term "tailgating"; opposite is a vintage view of Spring Street, Williamstown, on a football weekend in November 1955.

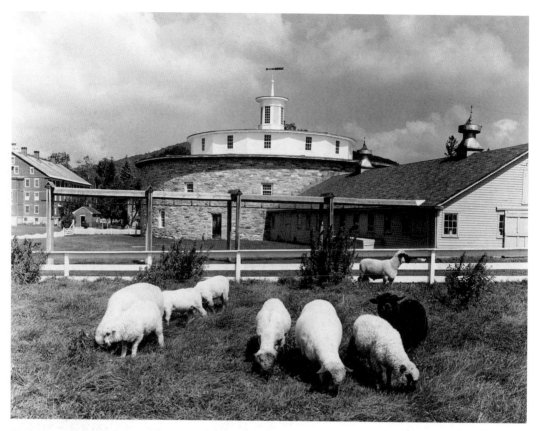

The Shaker tradition forms a strong cultural element in the Berkshires, symbolized by the restored Round Barn at the Hancock Shaker Village shown above. Since the 1960s, the village has been a popular site for visits by residents and tourists.

Opposite: Simple architectural symmetry is evident in this building of Shaker origins on the Darrow School campus.

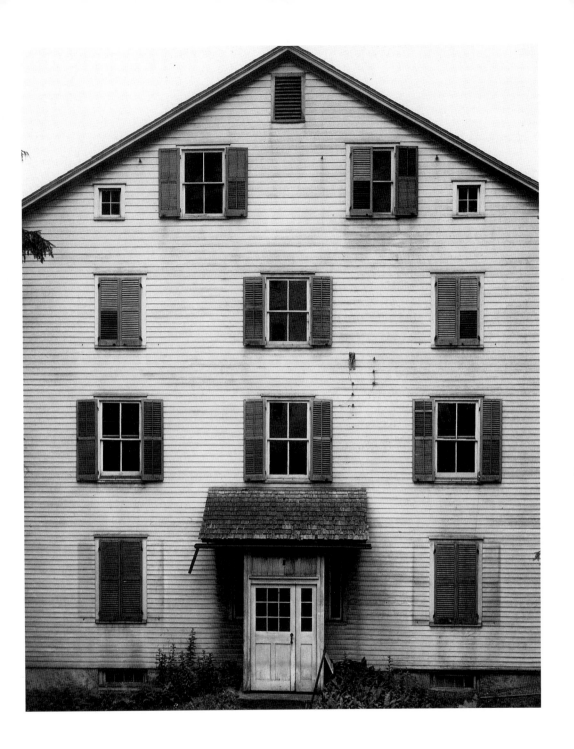

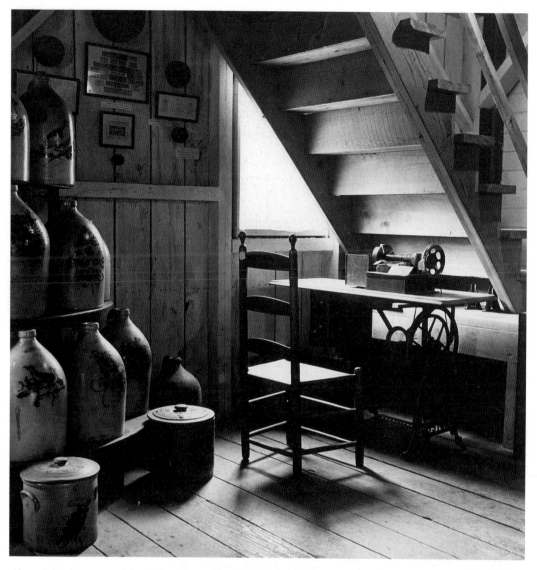

Above: A bright corner of the Shaker Museum at Old Chatham, New York, shows off a nice collection of regional stoneware jugs.

Opposite: Two of the last Shaker residents at Hancock, Eldress Emma King and Elder Ricardo Belden, are shown in photographs taken about 1960.

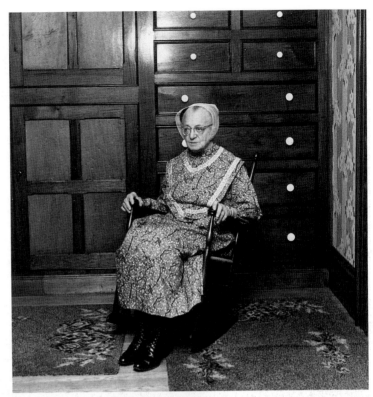

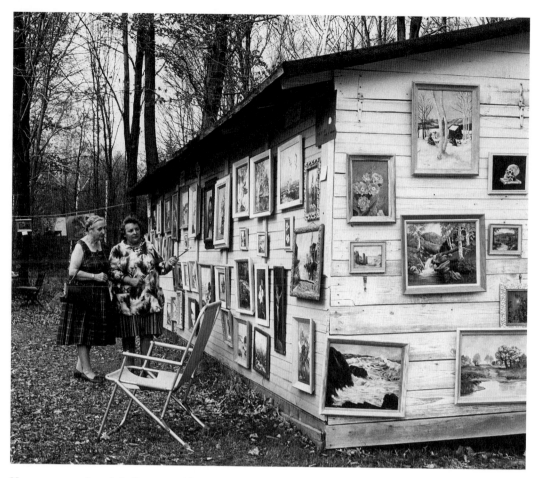

Home-grown culture is in frequent evidence during the summer and fall. The photograph above shows artistic roadside offerings at Lanesboro in October 1963; and opposite is an art show in Lenox in July 1972.

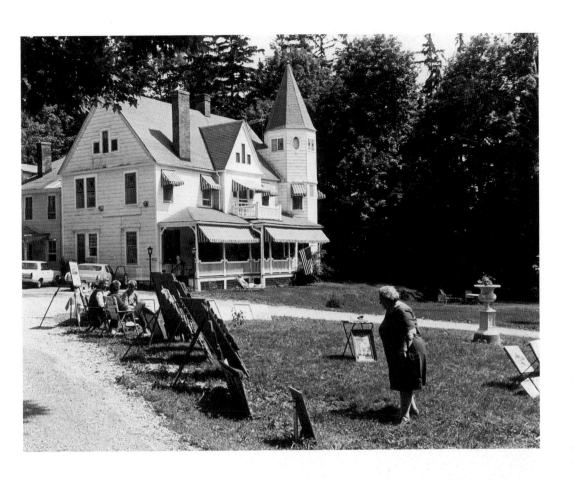

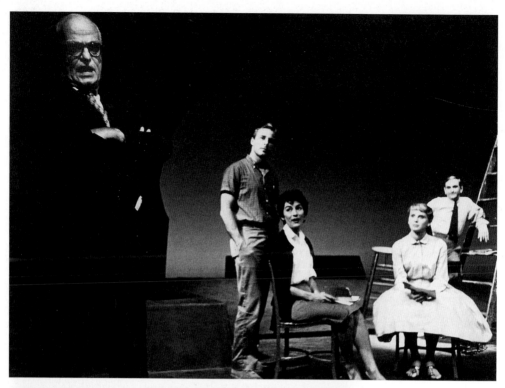

Above: Playwright Thorton Wilder, twice a Pulitzer winner, acts as stage manager to rehearse his *Our Town* with the cast at the Williamstown Summer Theater Festival in August 1959.

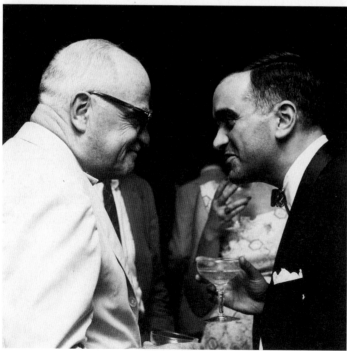

Left: Thorton Wilder makes good eye contact with Nikos Psacharopoulos, longtime director of the Williamstown Summer Theater Festival, in August 1959, when Wilder took the role of stage manager in his play *Our Town.*

seven

New Angles
on Old
Churches

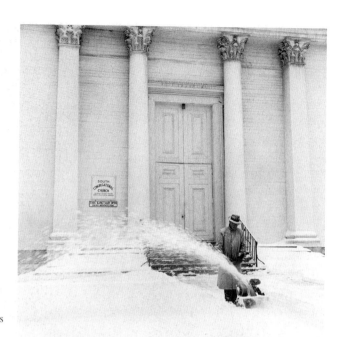

White on white: an undated but evocative view of ancient Greek architecture and modern technology at work. The church is the South Congregational in Pittsfield.

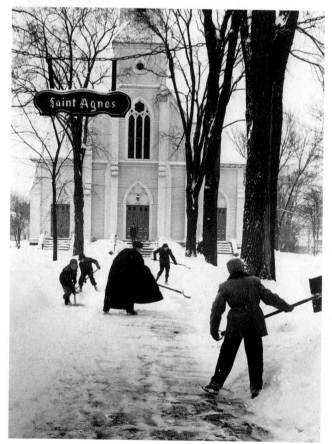

Left: Everyone pitches in to shovel snow in preparation for mass at Saint Agnes Church in Dalton.

Opposite: A glorious autumn view of the Church on the Hill at Lenox.

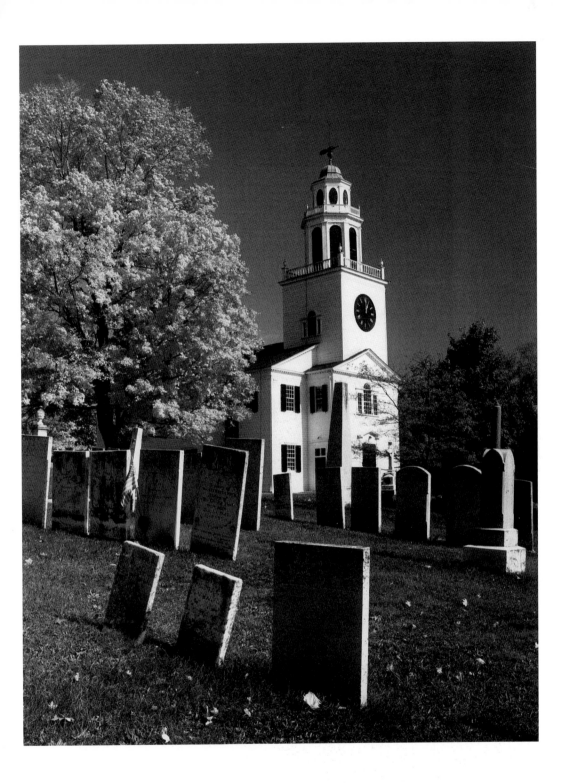

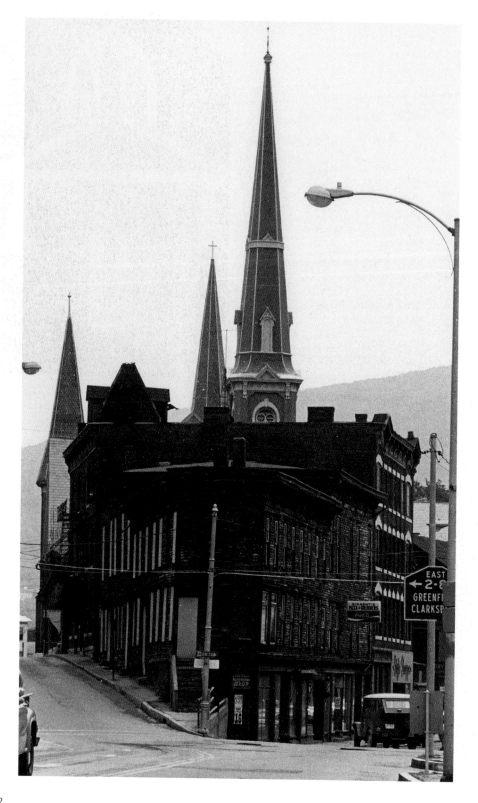

A sharp corner in downtown North Adams (*opposite*) discloses several church spires.

Right: The North American Martyr's Chapel in Lanesboro in May 1974.

Below: Mount Carmel Church lets out on Fenn Street in Pittsfield on a fine spring day in the 1960s.

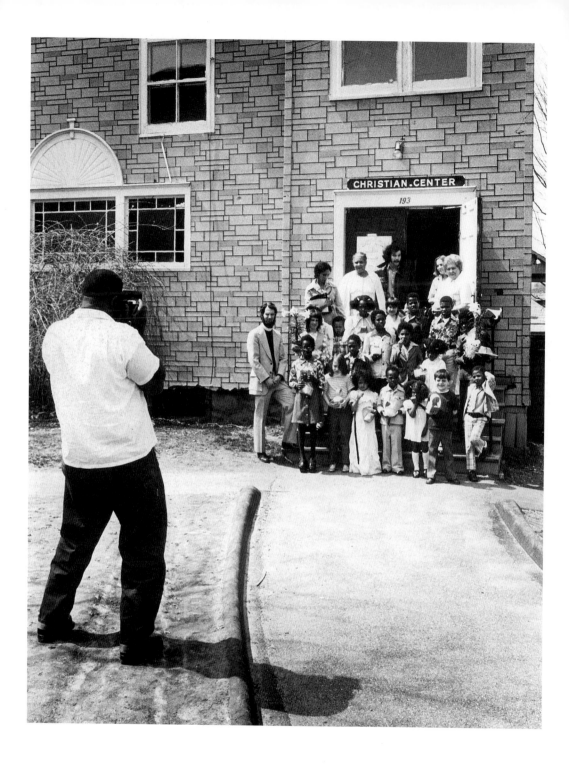

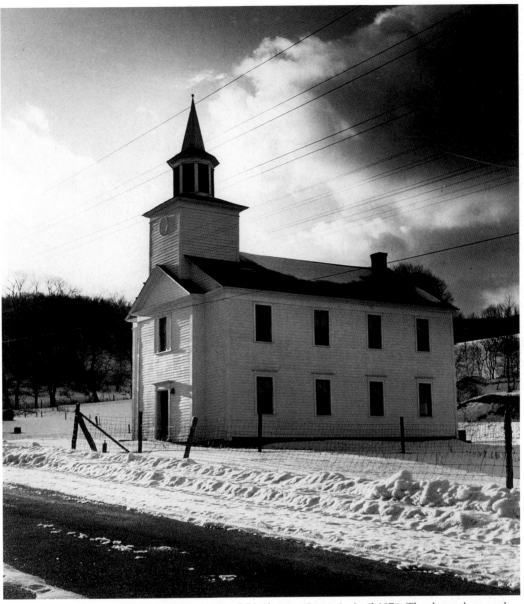

Time out for a snapshot (*opposite*) at the Pittsfield Christian Center in April 1976. The above photograph shows a picturesque community church in New Ashford, near the Brodie Mountain ski area.

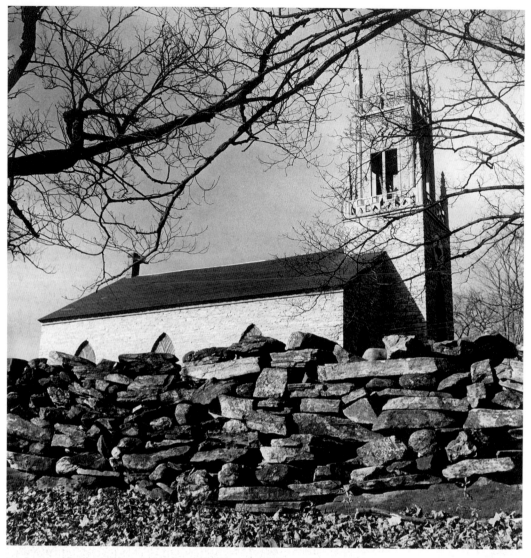

These are two views of one of Berkshire County's most scenic churches, the stone St. Luke's Episcopal Church. Built in 1834, it is located on Route 7 in Lanesboro.

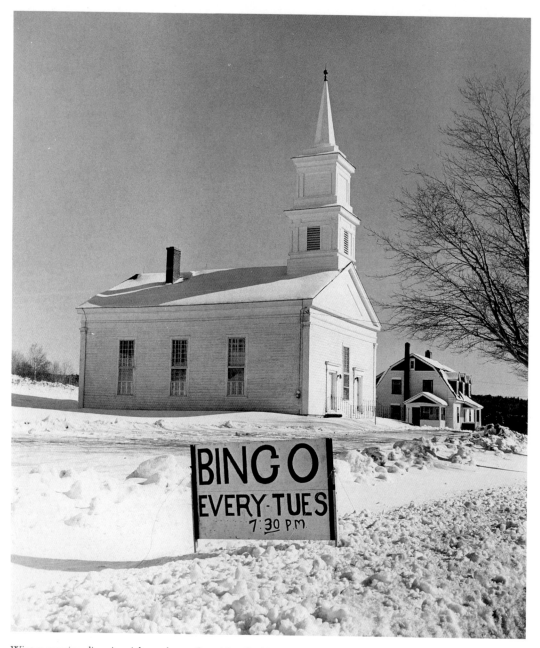

Winter-evening diversion (plus a chance for raising funds) is advertised at the handsome church in the high-elevation town of Windsor.